Art Workshop with Paul Taggart

Watercolour Painting

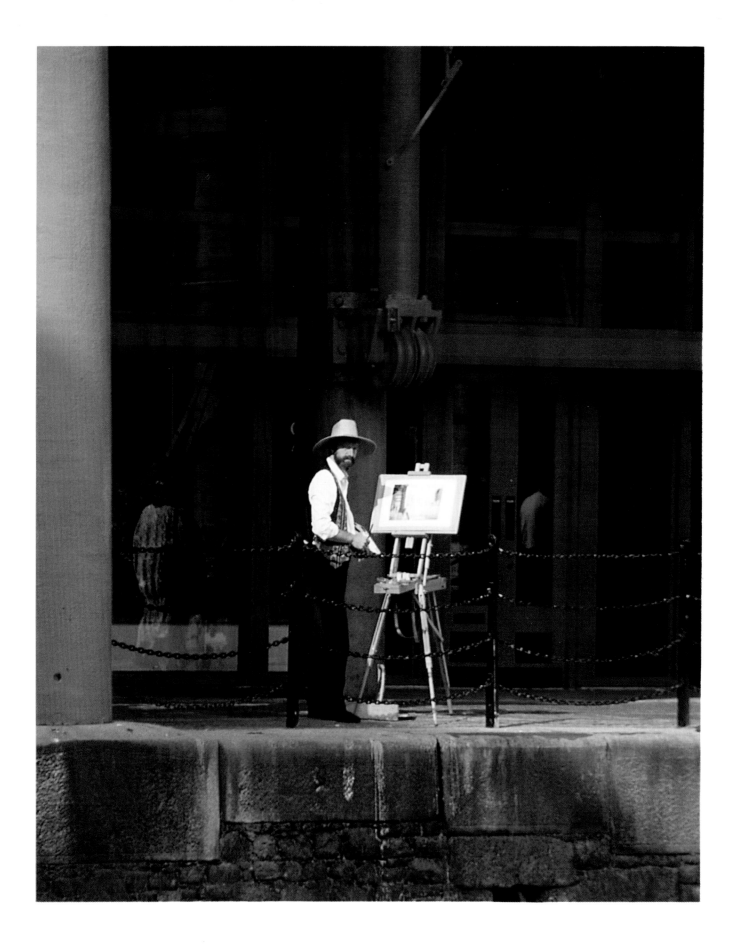

Art Workshop with Paul Taggart

Watercolour Painting

EBURY PRESS
London

For Eileen who held my hand
and my heart through the hard times

First published 1992 by Ebury Press
an imprint of the Random Century Group
Random Century House
20 Vauxhall Bridge Road
London SWIV 2SA

Editor: Cindy Richards
Designer: Behram Kapadia

Set in Linotron Melior by Textype Typesetters, Cambridge
Printed in Hong Kong by L. Rex Offset Printing Co. Ltd

A catalogue record for this book is available from the British Library

ISBN 0 09177016 5

Contents

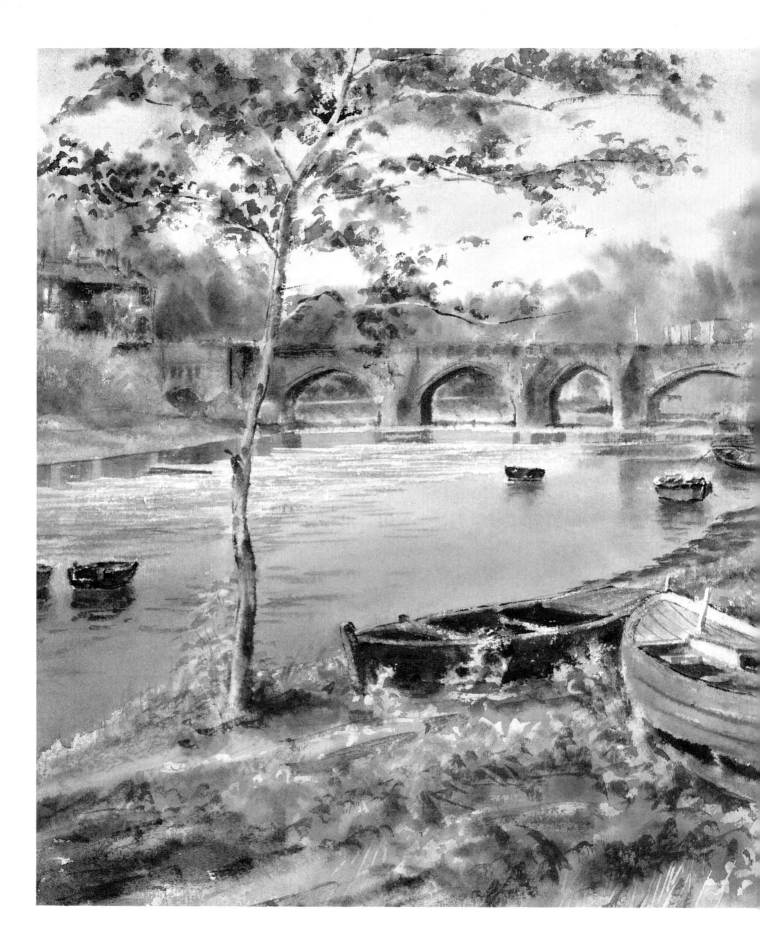

'If only I could paint or draw.'

This is what most people say to me when I meet them for the first time. My response is to suggest they have a go as they may be surprised at what they are capable of producing.

I won't pretend that it is easy; what I can say is that it is a very pleasing and rewarding pursuit.

You will find that painting focuses your observations of life. It will increase your ability to see the possibilities and excitement in even the simplest of visual experiences.

The versatility of watercolour from the simplest line-and-wash drawings to the rich, lustrous results of a combination technique, make it attractive to artists at all levels of competence whether you are a complete beginner or a professional. It possesses a brilliance and transparency of colour which cannot be matched by any other medium. At its most lustrous, its glowing effect can be likened to a stained-glass window with the sun streaming through.

Its versatility means that you can use watercolour to portray practically any subject, whether it's a small delicate flower or a dramatic portrait, as it is capable of both fine detail and bold strokes.

Before you begin

When I first started watercolour painting, in my early twenties, it would be fair to say that all I knew was which end of the brush to use. Looking around at other artists' work there appeared to be many different and confusing approaches to the medium. When I first started experimenting, I had no idea where I was going and what I was trying to do.

Some research was called for and so off I went to the local library, seeking enlightenment as to the definitive approach. What I found was that every artist has his or her own approach. While there was nothing wrong in that, it was of little help to me.

What I needed was a book that explained how to start, what to use as subject matter, how to hold the brush, how many layers of colour to use, how to mix them, and so on – the list was endless.

After years of painting, I now look back and begin to appreciate the interrelation of all the techniques and the endless approaches this offers.

I conceived this book for those of you who are coming to this medium for the first time and for those with a little experience who have come up against some of the barriers that I also experienced. I have tried to create the book that I needed in my early days, and I hope that it will serve that purpose for you for many years to come.

I have approached this vast subject by breaking it down into three main sections: line and wash; wet and dry; and wet on wet; followed by a short section suggesting how these techniques can be used in combination.

If I were starting off with this book I would read through from beginning to end, to get an overall grasp of the medium. Returning to the first chapter I would then work through using the artstrips as my principal teaching aid.

The artstrips are crammed with different techniques. Don't be frightened by all this information; you needn't master each and every one of them before you begin painting. I have attempted to cover most approaches and it may take quite some time, possibly even years, before you find the need to utilise all of them. Look upon the artstrips as a menu for you to select from. If you were in one of my classes I certainly wouldn't expect every technique to be incorporated in your first painting. Approach the techniques gradually, letting each idea stimulate a fresh painting.

Don't be put off by the word 'technique', nor allow yourself to become a slave to it. Many art tutors refuse to teach technique. Why? Well, in my opinion it may be that they see it as a bag of tricks, which their students will then employ time and again as a simple formula to create a successful piece of work. I grant you, this can and does happen. However, anyone who is slightly imaginative will find that their ideas are ahead of their capabilities. Those who set themselves a challenge and break new ground add vitality to their work. Technique, while providing a secure grounding, should not become the master.

Now to begin

When someone takes up painting for the first time there is often considerable pressure on them to produce the first piece within a few weeks. This should not be so. It is a totally new experience and as such it will feel a little strange and take time to get used to. So relax and don't hurry. Only through practice will you gain confidence.

Give yourself time. Don't feel you have to show each piece of work to family and friends unless, of course, you can trust them to have a positive approach. Criticism without sound advice is counter-productive. As we are constantly attempting to improve our work, it is natural that we see only the mistakes. However, it is just as important to recognise the areas that have been successfully painted.

Don't be worried about using photographs as your subject matter. You may even wish to copy some of the paintings in this book to get you going. What is important is that you are painting. Most professional artists started out with an ability to copy. If you can do so fairly accurately, you can assess what you are capable of producing. Eventually, as you gain more experience, confidence and a greater visual memory, you will gain more and more control over your composition. You will gradually inject your personality into your work. This is a natural process, which will require no conscious effort. It is essential, however, that you spend time at your easel for this natural talent to develop.

Be patient with yourself. In my early days I would estimate that a good three-quarters of my efforts ended up in the wastepaper bin. Don't despair – even a professional artist has bad days. When your painting goes well, your heart will soar, justifying all your hard work.

Finally, there is no feeling quite like that of hanging up the end result on the wall.

Colour Mixing: Artstrip

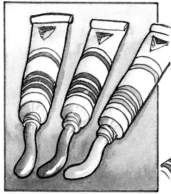

Red, yellow and blue are the primary colours. They cannot be attained by mixing, only directly from the tube.

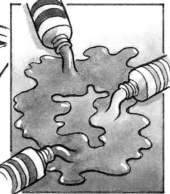

Primary colours mixed together give secondary colours: red and yellow = orange; red and blue = purple; and blue and yellow = green.

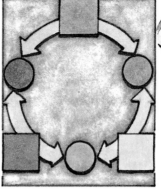

These then are the constituents of the colour circle.

Pure primaries do not exist. The mixes can be unexpectedly dull, e.g., cadmium red and Prussian blue should give purple, but they actually produce a muddy grey colour.

This is because all primaries have a bias towards the secondary they best mix. By using compatible primaries we can achieve a bright secondary.

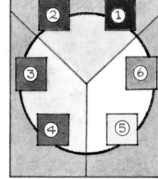

Using my basic palette you have two of each primary: cadmium (1) and crimson red (2): ultramarine (3) and Prussian blue (4): lemon (5) and cadmium yellow (6).

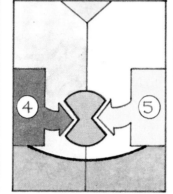

Mixing close primaries creates a bright secondary as they have a compatible bias, e.g., Prussian blue and lemon yellow give a bright green.

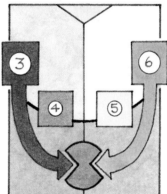

Distant primaries mix to produce dull secondaries, e.g., ultramarine and cadmium yellow give a dull green.

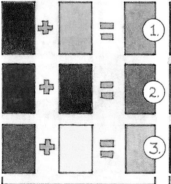

Try mixing compatible primaries: cadmium red and cadmium yellow (1); ultramarine and crimson red (2); Prussian blue and lemon yellow (3).

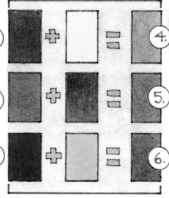

Then try mixing the distant primaries: crimson red and lemon yellow (4); Prussian blue and cadmium red (5); ultramarine and cadmium yellow (6).

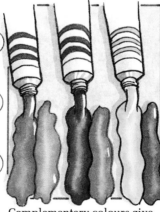

Complementary colours give tremendous contrast when placed next to each other.

But mixing complementaries produces a very dark, dull colour, e.g., red and green produce a nearly black colour. Try the other complementary mixes.

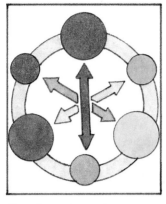

Complementary colours are found opposite each other on the colour circle.

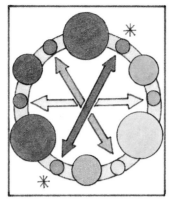

Tertiary colours can also be complementary to one another as they face each other on the colour circle.

When you mix complementaries you are in fact mixing all the primaries . . .

. . . The resultant mix absorbs all light falling on it and we achieve black (or a dull grey).

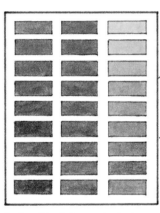

Before black is reached, the colours progress through a whole range of subtle changes. Try other complementary mixes to find out the position of differing browns and greys.

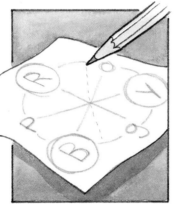

It's a good idea to always draw out the colour circle before you begin a painting so you become familiar with the complementary colours.

You can now change a colour's hue by adding another colour near to it on the colour circle, e.g., add yellow to red and change its hue to orange.

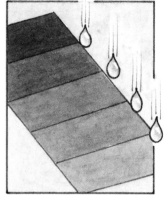

You can change its tone or value (its degree of lightness or darkness) by adding water or more of the same pigment to the mix . . .

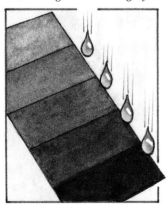

. . . and also by adding its complementary.

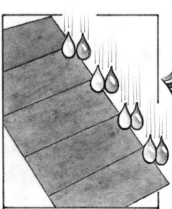

If, as you add its complementary, you also add water, the colour will not become darker, only duller. This is a change of intensity.

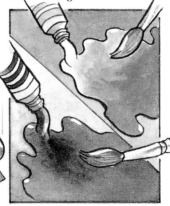

Adding white to a colour produces a tint; adding black to a colour produces a shade.

Tinting strength is the staining power of a colour. If you mix equal amounts of Prussian blue and yellow, the resulting colour will be blue rather than green.

General Hints: Artstrip

Watercolour paper is available in a variety of different weights: 1. 200 gsm (90 lbs); 2. 300 gsm (140 lbs); 3. 425 gsm (200 lbs); 4. 600 gsm (300 lbs).

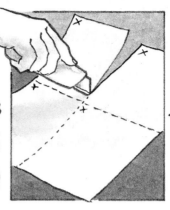

Hold paper up to the light. If you can read the watermark this is the surface on which you should work.

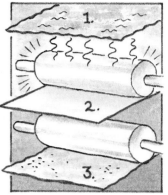

If you are going to cut the sheet, mark the corners to denote the correct side.

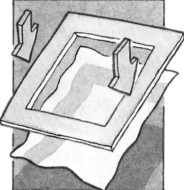

Watercolour paper is available in various finishes: 1. Rough; 2. Hot Pressed Smooth; 3. Not or Cold Pressed.

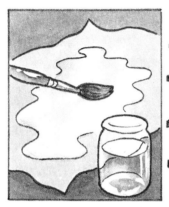

All paper will cockle to some degree when wet, making painting difficult.

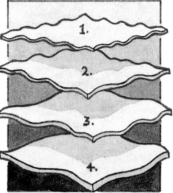

The thicker the paper, the less it will distort. 1. 200 gsm (90 lbs); 2. 300 gsm (140 lbs); 3. 425 gsm (200 lbs); 4. 600 gsm (300 lbs).

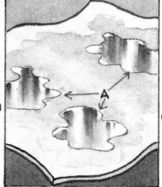

Cockles can cause pools of wet colour, which result in uneven drying and unwanted hard edges (A).

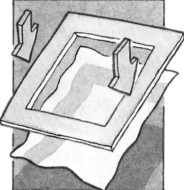

When dry, the cockles that remain make window mounting difficult.

In a watercolour block, the paper edges are glued together and fixed to a backing board, to avoid minor buckling.

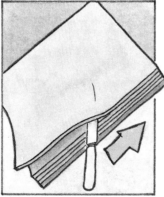

When the paper is dry, remove by inserting a blunt knife between sheets and separate as if opening a letter.

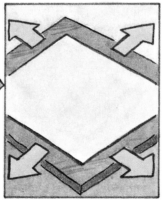

You can stabilise the paper effectively by stretching it on a board.

Your board should be made from natural wood, not a composite. It should not be varnished, laminated, or be water resistant.

Stretching Paper
Wet paper expands and when fixed at its edges will contract and stretch as it dries.

If your paper is thin, 200–300 gsm (90–140 lbs), wet both sides with a natural sponge.

Wet 'wrong' side first as this will pick up dirt from the board.

Thicker papers, 300–425 gsm (140–200 lb), run both sides under tap to soak.

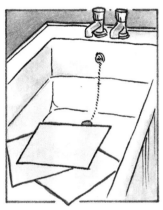

Leave 425–600 gsm (200–300 lbs) papers to soak in a bath of cold water for 10 minutes. This allows all the paper fibres to expand.

Excess water should be run off. Reverse hold to achieve even water distribution.

Position on board and squeeze out large air bubbles from the centre using clean hands.

Cut gumstrip to length. Keep it well away from water to prevent whole roll sticking together.

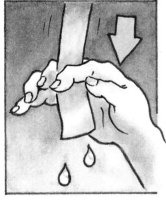

After thoroughly wetting the gumstrip run it through your fingers to remove excess water.

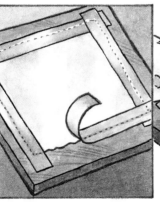

Stick paper on to board so that half the gumstrip is on board and half on paper.

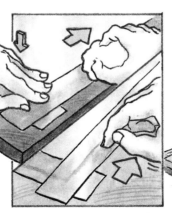

Holding the corner, press tissue along gumstrip (*top*) – the overlap of tissue picks up any water squeezed out. Ensure paper is stuck down by running nail along edge (*bottom*).

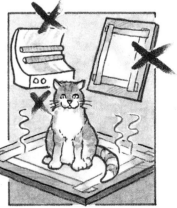

Leave flat to dry naturally. Avoid artificial heat sources and cats!

Thumbnails: Artstrip

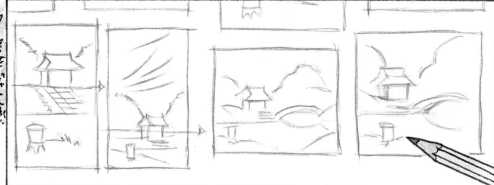

At the start of any painting you are faced with a confusion of detail. How do you decide where to begin?

By drawing a series of thumbnails (tiny simplified line drawings) on any spare piece of paper you can decide what to include or exclude. Note how the format of the

rectangle is varied as well as the proportions and contents within. If you don't have time to paint on the spot and have to take photographs, still spend five minutes on

thumbnails. They will help you compose the photograph and later will remind you exactly what you were attempting to capture in the scene.

Alter actual proportional relationships if it benefits the composition.

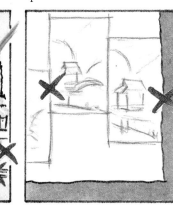

Be selective – miss out details which might spoil the balance or mood of the picture.

Thumbnails should not touch each other or meet the edge of the paper. This leads to confusion and unbalanced compositions.

Remember, thumbnails are not drawings but are preparatory sketches. Keep them fast and simple.

Block in simple tonal values on your favourite thumbnail using the edge of a graphite stick. This helps to confirm your decision and get a feel for the finished painting.

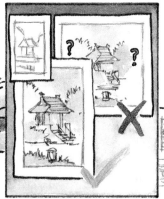

Make sure your painting is the same proportion as your thumbnail.

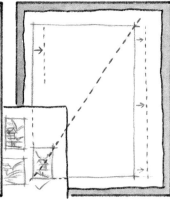

Turn your paper to the correct format (landscape or portrait) and use the method shown above to achieve the correct proportions. If off centre move across paper as required.

Using the thumbnail as a guide, sketch in a rough grid or skeleton composition. Keep lines as straight as possible. Add curves later.

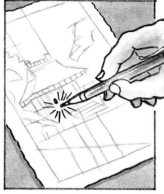

Fill in bones of drawing with a 0.5 mm clutch pencil (2B). Lead snaps if you are pressing too hard and this prevents heavy linework. Don't shade.

Using a ruler gives straight lines but tends to produce heavy, non-descriptive linework which is difficult to erase if incorrect.

Always use a putty rubber when erasing. A dabbing motion is useful for partially removing or lightening linework and causes less damage to the paper.

Using these techniques will produce a light line that can easily be covered with washes of colour.

A 2 mm pencil line is much more difficult to paint over. This makes it excellent for line and wash but unsuitable for preliminary drawing with other techniques.

Brush care
Never leave brushes loaded with paint to dry out. This damages the hair.

Rinse out immediately and, at the end of a session, wash on surface of a bar of soap or proprietary fine-art-brush cleaner.

If paint accidentally dries on brush never crack the dry paint off but soften gently in a basin of cold water, then clean with soap as before.

Work cleaner into the base of the hairs with a fingernail as paint collects here and dries.

Rinse out thoroughly under cold-water tap. Never leave brushes standing head down in water as they become misshapen.

Point brushes and stand upright in a jar to dry.

When dry, store safely away on a piece of corrugated card. Avoid moth attack by using moth balls.

Line and Wash

Lying at the boundary between drawing and painting, I always like to think of line and wash as 'drawing with colour'. The information is carried by the line while the paint adds solidity, colour and mood. The former is therefore of paramount importance. Keep this in mind as you work and you will not go far wrong. If the washes of colour become too strong, they will overpower the linework, and you'll have to take remedial action (*see page 48*). Remember, whether you complete the linework at the beginning or end of the picture; it should always work in its own right, without the addition of colour. Even tone and texture can be achieved through line. The colour with which you overlay them can then be beautifully thin and transparent exploiting the inherent qualities of the watercolour. Don't restrict yourself; apply the colours in a loose and casual manner, going over the lines if you wish. Line and wash is all about looseness and freedom, so relax your grip on brush and pen and enjoy the qualities this allows and the exciting visual results it produces.

For the beginner

Line and wash is about drawing, a word that often instils fear in the beginner. It shouldn't, however, as it doesn't mean you have to possess great technical expertise achieved through years of training. Drawing simply means recording or reacting to what you observe. I have seen line drawings with the complexity of a spider's web and others as simple as a child's scribble. Each of these approaches has its own intrinsic beauty. Think of how loose your wrist and hand become when you sign your signature. Try and imitate this when drawing. One of the best pieces of advice I can offer to someone trying this out is to remember that the quality and freedom of line is more important than accuracy – so go ahead and enjoy yourself, you may be surprised by the results.

Adding colour

When it comes to adding colour, beginners often freeze. The answer is to keep the colour simple and transparent and you won't go wrong – believe me.

Line and Wash

In England a whole landscape tradition was founded on the line-and-wash technique whereby a tonal rendering of the subject was completed using an indelible medium to which colour was later added. You could, for example, produce the line and shading using only Indian ink by laying down thin washes to produce a range of greys from off-white to near-black. The final addition of watercolour would serve only to add definition, or perhaps to create a particular mood or atmosphere (warmth or coldness, for example). It is an excellent technique for the beginner, as tone and colour are kept totally separate and added to the painting

at different times. Recently this method has lost favour as the colours lose some of their intensity with the black or sepia washes underneath. However, the tones created by these underlying ink washes can help unify the colour range and I think this method still has much to recommend it.

In the field

As line and wash is primarily drawing, why not complete the line part of your painting on the spot and the colour when you return home? This means all you need to take with you in the field is a sketchbook and pen which are inconspicuous to use. This is important for the beginner who does not wish to be noticed by inquisitive passers-by.

In the studio

When you return home to work on a painting, try to keep it fresh and don't be tempted to overwork it. Use the time and privacy available to you in the studio to increase your speed and develop the looseness required for working in the field. Don't spend the time 'tickling' your painting.

● Finally, let me say that line and wash is one of the most popular watercolour techniques with both artists and the buying public – probably because it combines the freshness of painting with the detail of a drawing. It has links with etching and engraving, whose images are also built up using line. These are often coloured with watercolour washes, producing a similar effect to that of line and wash. One day you may try your hand at these other processes, having explored this fascinating watercolour technique.

Tubes of Artists' watercolours for laying large areas of wash. These semi-liquid colours dissolve quickly and evenly. (*From left to right*) cadmium red, crimson red, ultramarine, Prussian blue, lemon yellow, cadmium yellow

Half pans of Artists' watercolours which will dissolve easily to cover small areas of wash. (Always buy Artists' watercolours *not* watercolours for artists, the latter is often student quality.)

Inks – use either waterproof Indian ink or a coloured, lightfast, waterproof ink.

A ceramic or plastic palette like this one with deep wells is essential for the large quantities of diluted colour needed for this technique.

Two jam jars with lids act as a portable water supply. One should be used for cleaning brushes and the other kept fresh for mixing colours.

A plywood drawing board, 2 cm (¾ in) thick with sanded edges. It should be 5 cm (2 in) wider on each side than the largest piece of paper you plan to use.

Good-quality watercolour paper – I would suggest you try using a 300 gsm (140 lbs) paper.

A small palette for ink or masking fluid. Both should be kept separate from your main paint mix.

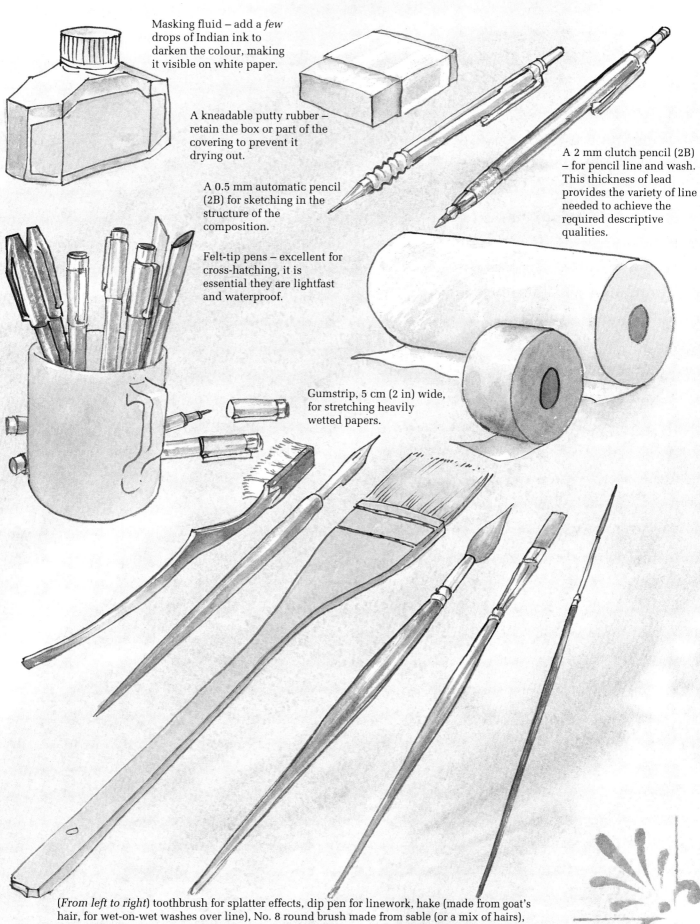

Masking fluid – add a *few* drops of Indian ink to darken the colour, making it visible on white paper.

A kneadable putty rubber – retain the box or part of the covering to prevent it drying out.

A 2 mm clutch pencil (2B) – for pencil line and wash. This thickness of lead provides the variety of line needed to achieve the required descriptive qualities.

A 0.5 mm automatic pencil (2B) for sketching in the structure of the composition.

Felt-tip pens – excellent for cross-hatching, it is essential they are lightfast and waterproof.

Gumstrip, 5 cm (2 in) wide, for stretching heavily wetted papers.

(*From left to right*) toothbrush for splatter effects, dip pen for linework, hake (made from goat's hair, for wet-on-wet washes over line), No. 8 round brush made from sable (or a mix of hairs), flat nylon brush (1 cm (⅜ in), for painting and lifting off colour), nylon rigger for linework.

Line and Wash: Materials and Preparation

In line and wash, the line is the descriptive element and therefore takes priority over colour and texture. I chose my materials with this bias in mind.

The paper must take the line well. Many artists choose a Hot-pressed paper as its smooth surface enables them to produce a delicate and controlled line. Personally, I prefer a Rough paper. This can break up the line quality somewhat, but I like this effect and use it intentionally to create a 'scumbled' line. I find that papers with higher concentrations of surface size (*see page 90*), whether rough or smooth, pick up the line well. Tub-sized papers are especially good, even if the extra process involved in their manufacture makes them more expensive. The paper needn't be stretched if it is of a reasonable thickness (425 gsm (200 lbs) or over) and is not going to be heavily wetted. This is unlikely with the light washes required for this technique.

I always follow the rationale that if you do not have the right tools, you cannot do the job properly. After all, when considering the overall price of a painting, what difference does an extra few pence make for the right materials? This is especially true if you eventually hope to sell the painting. Producing a piece of work with the right equipment can make the difference between producing an adequate painting and an outstanding one.

The brushes used for line and wash are the same as those you would use for wet on dry (*see page 50*) and/or wet on wet (*see page 85*). The rigger, a brush designed for linework, is the only one specific to this technique. It is so named, because it was used for painting the rigging in paintings of sailing ships. It differs from an ordinary 00 sized round brush, which produces the same thickness of line, because the long body of the rigger holds more paint and you don't have to keep refilling it.

A variety of pens can be used although I would avoid mapping pens as they are generally too fragile and, unless you are producing a postage-stamp sized painting, will disintegrate over large areas.

Dip pens with drawing nibs are excellent. Make sure the nibs are not italic by checking they come to a point and not a flat edge. You may want to use an italic nib for certain marks, but generally they will impede the fluidity of the line. The pen should yield a change of line thickness as you increase or decrease the pressure it exerts on the paper. The italic pen changes thickness as you change direction, a difficult quality to control.

All *ink*, whether in a felt-tip pen or a bottle, must be lightfast and waterproof. Even Indian ink is made in a water-soluble form today which can prove disastrous if the line is drawn before the application of colour washes. The examples shown in this chapter were all created by drawing in the line first. Some artists prefer to lay their washes first and then tighten up with the linework. If you prefer to work this way your ink need not be waterproof and you could even produce the line using watercolour.

For line and wash, the amount of pigment used in the washes is quite small, and therefore you can use either tube or pan colours.

The tube colour, as it is already in a semi-liquid form, dissolves quickly and is good for covering large areas of wash. Pans, on the other hand, being dry paint, need more time to soften and dissolve and are best used for smaller washes or detail. I would always advise buying Artists' quality, rather than Students' quality, as the pigment is more finely ground and therefore dissolves easily saving time and, most importantly, wear and tear on your valuable brushes.

Select your subject and complete your batch of thumbnails (*see pages 14–15*). First of all, make sure the subject you have chosen is suitable for interpretation using this technique. You would not, for example, depict a foggy or damp atmosphere using line and wash, as it is too precise. Nor would you attempt a subject which was very dark, as the dark washes would probably obscure your linework. Something light and fresh, with detail, is perfect.

Do not expect a painting at your first sitting. Give yourself time to explore the potential of all your materials before you attempt a finished piece of work. Look at the wonderful pictures children create. They respond quite naturally to the qualities of their materials and are not restricted to representing their subject in a photographic way. If you spend time getting the feel of your paints you will become aware of their abstract qualities. Although I am not advocating that you attempt an abstract painting, it is important that you are aware of these qualities which, if used successfully, will enhance your work no end.

I save all my offcuts of watercolour paper for experimentation. Even now, before I use a rigger on my painting, I spend a couple of minutes loosening up my wrist on a piece of scrap paper. This reminds me of the possibilities inherent in the brush, the paint and the surface on which I am working.

Make sure that everything you need is close to hand. You do not want to stop in the middle of a creative frenzy, to search for your materials.

Now to the most important part of the preparation – that of your mind. You need to be relaxed to paint. Try and build up your energy and concentration until you know the painting will go well and that you are going to have fun. This is not easy, but as you paint more you will become adept at this relaxation technique – why do you think it is that painting becomes so compulsive?

Artists' colours in tube or pan form. Tubes for covering large areas and pans for smaller areas or details. Keep paper wrappings from pan colours.

A cheap way of storing your pans is to secure them inside a cardboard box. Use wrappers to identify colours as it is difficult to distinguish between dark pigments.

If you buy a metal box, designed for holding pans, stick wrappers adjacent to relevant colour so you can identify them quickly and easily.

Dip pens with interchangeable drawing nibs give fine, medium or thick lines. Using this type of pen you can quickly change the tone or hue of the line.

They are excellent for descriptive lining as the line varies gently according to the pressure applied. They are also useful for cross-hatching.

Felt-tip pens abound but do make sure they are lightfast and waterproof. Unfortunately, they soon lose their points.

Some are manufactured with a metal sheath over the fibre tip. This can extend their life. Remember, always replace cap when not in use.

In technical pens, a metal tube carries ink to the tip. They should be held at right angles to surface to achieve an even line width. This line lacks variety and excitement.

Non-waterproof inks will dissolve into the wash. An interesting effect, but you may lose your line.

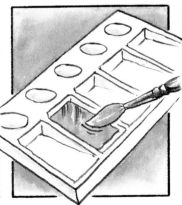

This deep-well palette can hold large quantities of thin colour.

Always test strength of colour by applying a thin layer of wash. Deep pools of colour in palette can look darker than they really are. Allow to dry as colours lighten on drying.

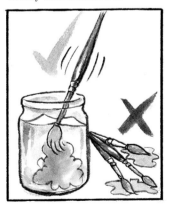

Never allow inks or even watercolours to dry in your brush. It damages the hair and brush will lose its bounce and point.

Line and Wash: Artstrip

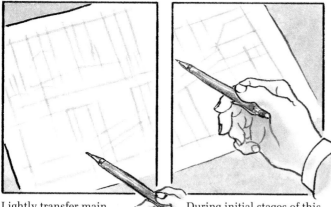

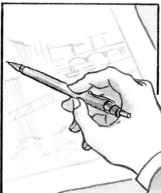

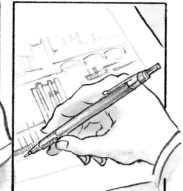

Lightly transfer main elements from thumbnail sketch to painting surface.

During initial stages of this process, hold pencil loosely to avoid heavy linework. Using a 0.5 mm automatic pencil will help keep the line gentle.

As you tighten up on detail move your hold further down the pencil shaft.

You will gradually gain more control and ability to vary the line strength. Use a 2 mm clutch pencil to cope with required increase in pressure.

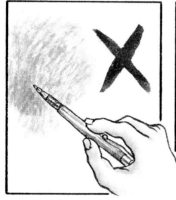

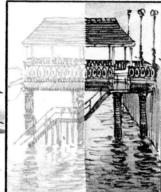

Avoid solid shading which will look dirty under a colour wash and, if too heavy, can even resist the watercolour.

You may decide that the linework is more than adequate in pencil . . .

. . . but a stronger line can take darker washes without losing definition (*right*) . . .

. . . and you may decide to use waterproof ink and a rigger.

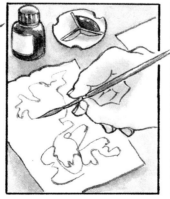

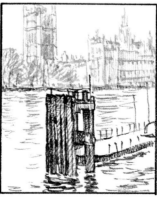

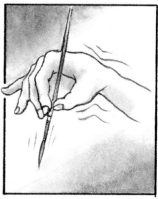

You will find the rigger responds well to differing speeds and pressures when applying the ink.

Practise your linework on an offcut before starting on an actual painting.

As the line carries all the information, it must be as varied and descriptive as possible.

Try to keep your wrist flexible. Remember, fluidity is more important than accuracy.

Shake ink well and transfer a few drops into a shallow cup.

You can water this down with distilled water (*see page 49*). To avoid over-dilution, transfer water drop by drop using a brush.

This watered-down ink produces faint lines which suggest depth or distance.

They can be finished off or overlaid with a full-strength line.

Erase all linework, gently, with a putty rubber.

By varying line thickness you can suggest volume. Try this out on a variety of subjects.

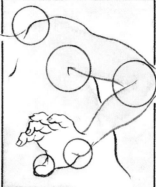

Over-lapping lines which suggest internal structures give a more descriptive outline. Find further examples to draw.

There are many other line qualities and a huge range of drawing implements available for producing them Try some out and discover what variety there is.

Cross-hatching or line-shading can be very mechanical (*top*) or very loose (*bottom*).

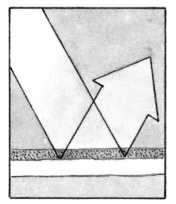

Since the richness of watercolour depends on light passing through the pigment layer and bouncing off the white paper beneath . . .

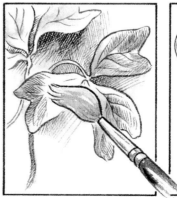

. . . shading using cross-hatching is acceptable as a certain amount of white is left which reflects the colour.

Varying the direction of the line can suggest volume, as can line thickness (as we have already seen) and spacing between lines.

Line and Wash: Artstrip

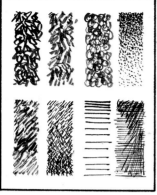

There are many different ways of drawing lines to create a variety of effects.

It makes sense to consider line and wash as a line drawing . . .

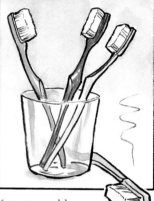

. . . rendered with broad areas of gentle colour.

The colour wash can overlap the line as it will show through even the darkest of washes.

A round brush can be used for 'scumbling' to create texture.

Try using the side of this almost dry.

Don't let the scumbled areas become solid as any overlaid colour will not show.

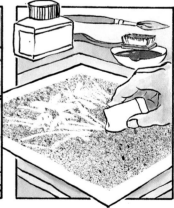

Keep your old toothbrushes . . .

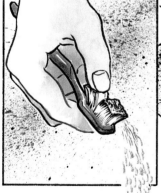

. . .their bristles are excellent for creating a splatter effect.

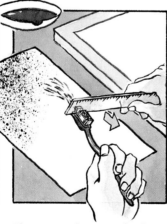

Always test the strength of your spray before applying it to your work.

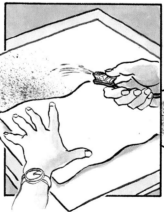

Cut out a paper shape to act as a mask to control splattered areas.

Masking fluid can also be useful to protect irregular areas from splatters. It is then removed with a putty rubber.

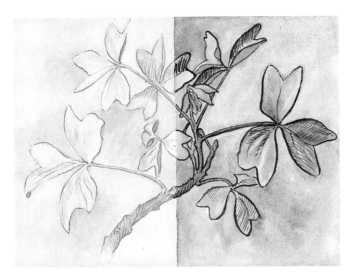

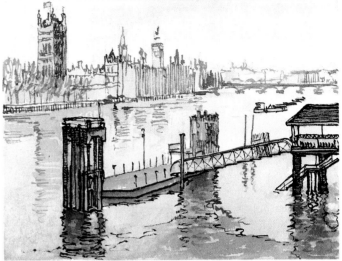

A pencil line dictates a gentle approach to the colour washes. Using ink allows a much stronger coverage without losing the line. Choose the one that is most appropriate to the qualities evoked by your subject.

Diluting the ink for distant linework gives a feeling of depth even before the addition of watercolour. Remember that the line not only controls where the washes are laid, but also the depth of colour.

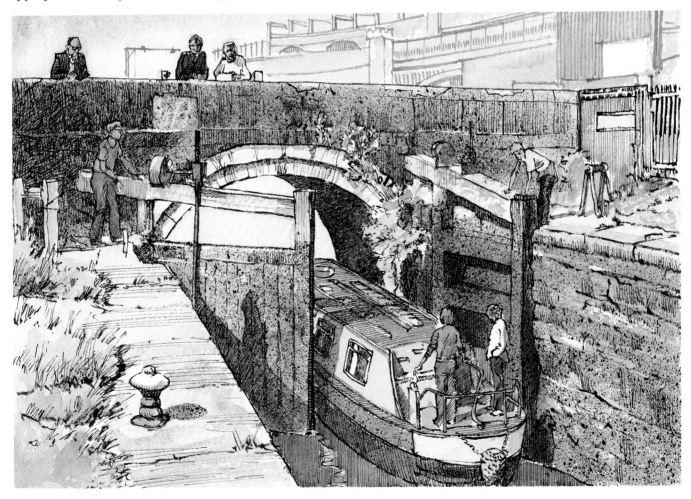

You can see from the picture above that all detail can be drawn in line and that the colour is a bonus. The textures and tones created by the lines simplify the work that the paint has to do. Line and wash is an excellent technique for those who like to draw and is a useful stepping stone between drawing and painting.

Line and Wash: Working From A Photograph

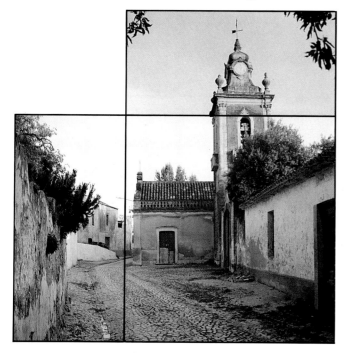

I came up against a very common problem, often encountered by the photographer, while trying to photograph this Portuguese church. I had found the ideal shot but could not get far enough away from the subject to get it all in one picture. The answer is to take a number of photographs and piece them together later. These are known as 'joiners' and are especially useful as you can capture more detail on the individual photographs than you could if you took one photograph and had it blown up. Here, I only needed two shots to capture the full height of the tower and the textured wall on the left, but I have been known to take up to a dozen.

In the upright photograph the exposure required to capture the richness of colour in the tower meant that parts of the street were lost in darkness. But fortunately, the horizontal shot of the street itself, with less sky exposed, brought up the wonderful details of the cobbled street.

If you do work from photographs, it is useful where possible to produce your thumbnails *in situ*. This exercise concentrates your mind and helps prevent you from taking disappointing reference shots.

1. My first thought – get it all down and see how it feels.

2. I like the texture of the wall on the left – perhaps I should make it more dominant?

3. A different format may be the answer.

4. What if I made a painting of the cobbled street with the buildings as a backdrop?

5. I like this upright format, but it feels a bit squashed.

6. That's better, but there is a large square of empty sky.

7. Perfect – I've managed to include the wall and retain a good negative shape for the sky.

Here I am starting off in the comfort of my studio. The joiner is fixed to the top of my easel and all my equipment is to hand.

I am satisfied with the proportions of my thumbnail, so I now have to ensure that they are correctly transferred to my paper which is, of course, much larger. I use very light pencil lines at this stage as they are easy to correct or adjust.

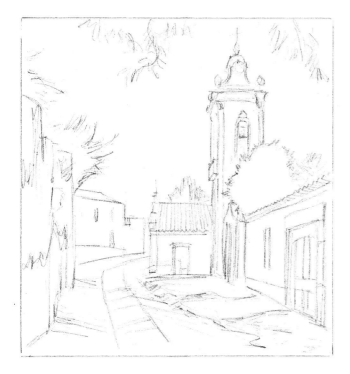

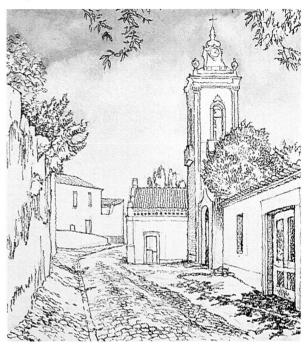

Once the structure is in place I can be more relaxed when applying details. However, I don't go too far as I want to allow myself freedom of expression when applying the actual linework. To that end I lightened the pencil lines with a putty rubber.

I decided to use a Chinagraph pencil for the linework as it gives a wonderfully dense but variable line. It is also waxy and will resist the watercolour washes. The rough Fabriano paper gives the line interesting textural qualities, but you could experiment with other papers such as Not or Hot Pressed.

(Continued on page 36)

Line and Wash: Working In The Field

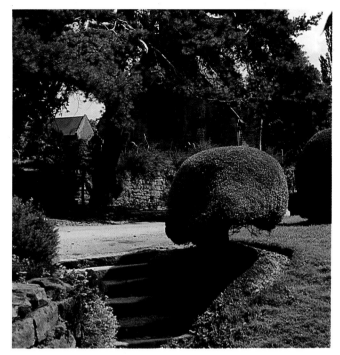

A painting can win hands down over a photograph where a view such as this is concerned. The church was framed by the foliage of the tree but, as it was in such dark shadow, it is difficult to distinguish. I wanted to retain the steps in the foreground as they lead nicely into the picture. However, as they are so close they appear two-dimensional. The poplar trees to the right are too small, in reality, to break into the large triangle of empty sky above them.

The photographer has to put up with all these problems and may never get a good shot from this angle. On the other hand, the artist can come along and, with a little adjustment here and there, can make improvements while keeping true to the overall spirit and quality of the view. So on with the thumbnails . . .

1

Steps too dominant – tree too small.

2

Tree still looks too squashed.

3

Letting the tree go out of the composition and concentrating on the church.

4

Can this change of format allow the whole of the tree back in?

5

The 'portrait' format is certainly the answer . . .

6

. . . but extra width gives breathing space and the tree is no longer trying to burst out of the top of the picture.

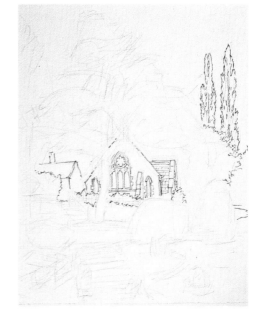

What an idyllic setting. However, even on such a wonderful day, I was well prepared. The hat is essential if you are going to be exposed to the sun for even a short period of time. You can't move around once you have started painting, so you will burn – usually down one side only. I also carry an insect repellent, sun barrier cream, a waterproof jacket, and of course an umbrella. A plastic carrier bag is handy for your rubbish, discarded tissues, etc.

My initial pencil drawing could be loose, even scribbly, as I was going to use ink and so it would be erased later. Beginning with the most distant parts of the composition, I started off the linework by using a rigger and very diluted waterproof Indian ink. Always mix the ink and water with a large round brush as the rigger is too delicate.

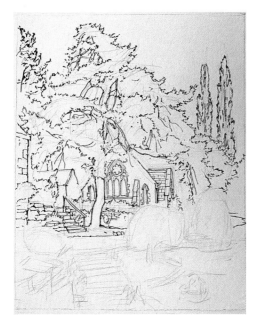

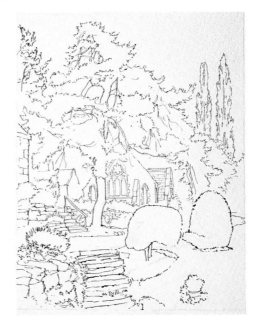

I strengthened the ink solution as I moved forward, having first tested it on a spare piece of paper and allowed it to dry. The line at this point, while being as variable in thickness as possible, was not used for shading, but for silhouetting the forms. Remember, it is always possible to reinforce the linework later, when balancing it against the colour washes.

The foreground was now completed in full-strength ink. With Indian ink it is impossible to erase mistakes, so keep the line loose and you will get away with it. Look at the second step down from the top in the foreground and check against the finished painting (*see page 47*). I got a little lost here, but in the end it doesn't show. It is the whole picture that is important, so don't worry about a few errors. The pencil lines were erased with a putty rubber, except for the shadow forms in the foreground.

(Continued on page 38)

Line and Wash: *Artstrip*

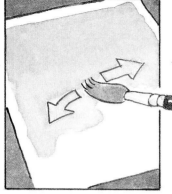

The simplest way of applying colour is to lay a wash across the paper . . .

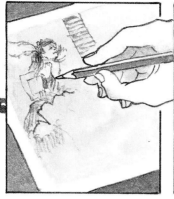

. . . and when dry complete with a line drawing in any medium (it does not need to be waterproof) – here I used a charcoal pencil.

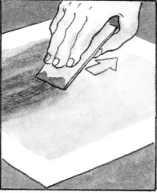

Alternatively, drag stiff colour (from tube) across your wet wash for an exciting textural background. Use a piece of card or tissue to drag or dab on colour.

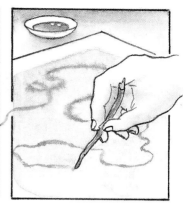

Why not apply coloured line with something unexpected? For example, use a piece of stick (*above*) or the quill of a bird's feather. Try this on a wet as well as a dry surface.

An alternative, very traditional, method – excellent for the beginner – is to draw in a gentle pencil structure.

Strengthen and correct linework with ink applied using a dip pen or increase strength of pencil line to give similar effect.

Loosen up line with a rigger.

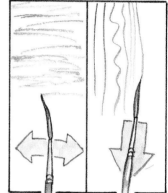

Note how direction of brush changes nature of line.

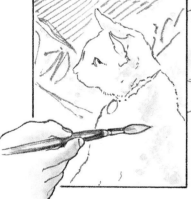

Protect any small highlights with masking fluid.

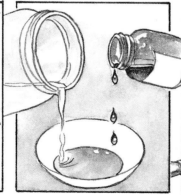

Mix together a few drops of waterproof Indian ink with a larger quantity of water in a small cup.

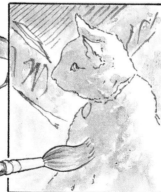

Apply ink mix over large areas of the painting with a large round brush, leaving large highlight areas exposed (*see cat's back*).

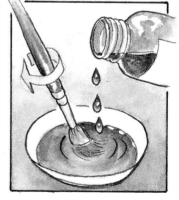

While allowing first wash to dry, add a few more drops of ink to diluted solution and mix well.

Apply stronger ink mix over areas you wish to be darker.

Using side of a round brush, sweep it across surface for even coverage. Do not dab as this causes pooling and gives an uneven texture.

Apply ink in layers until tonal structure of the painting emerges.

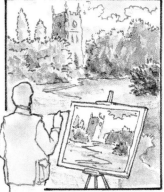

It is extremely useful, particularly for beginners, to analyse the tonal range of a composition in this way before adding colour.

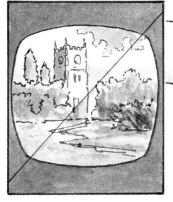

If you study a monochromatic image you realise that light, depth and volume are inherent features of tone. Colour is a bonus in depicting contrast and mood.

Now remove masking fluid, using a putty rubber, to expose the protected highlights.

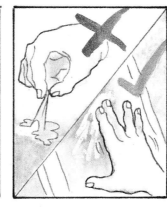

Don't be tempted to pull off mask as it can damage the paper. Run a clean hand across surface to find any hidden spots of masking fluid.

Colour can now be added to your work as a finishing touch.

Note how ink beneath wash holds colours together and adds contrast.

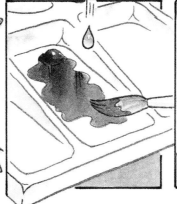

Another method you can try is to mix colour thickly using very little water until a cream-like consistency is reached.

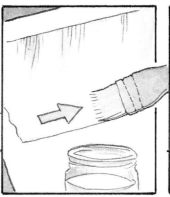

Wet the paper thoroughly and evenly with a hake.

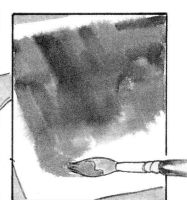

Block on colours thickly and leave to dry.

Line and Wash: Artstrip

Lift off colour to give lighter tones and white highlights (*see wet on wet, page 102*) using the chisel edge of flat nylon brush.

Apply linework using a strong solution of Indian ink.

To complete, apply colour to any lifted areas which look too white (*see finished work opposite*).

General observations: With pencil line and wash you can fix linework using a diffuser or aerosol before applying washes, so strength of pencil line is maintained.

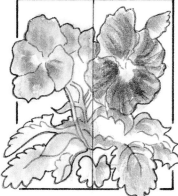

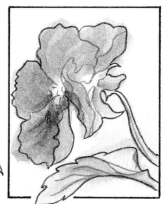

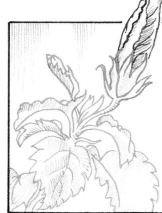

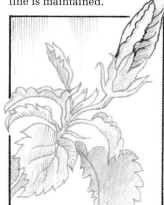

With ink line and wash, line is strong so washes can be wet on wet (*left*), or wet on dry (*right*).

Washes need not be restricted by outline – so feel free to loosen up application of colour.

Even more variety is obtained by changing line colour within same drawing.

This could echo colour in which each area is to be painted.

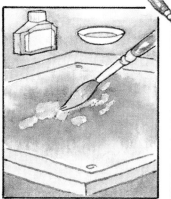

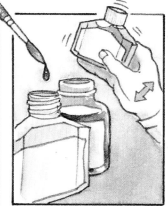

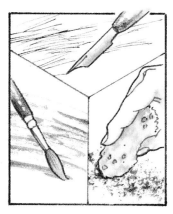

Masking fluid can be used over ink or colour washes. It will protect all it covers from the coming wash. It does lift a little of the colour when removed.

Add a few drops of Indian ink to bottle of masking fluid and shake well to make it more visible on the white surface.

Masking fluid can be applied with a brush, pen, sponge, stick, etc. – experiment.

Here masking fluid was used extensively around edges of the painting to create a vignette effect (edges fade away) when removed.

The subtle quality of the background has been achieved using lift off (*see page 102*). Note how the texture of the paper gives a glow to the colour.

A line drawing on a graded background is probably the simplest of line-and-wash techniques. Here the line has been drawn with a charcoal pencil.

A vignette painting created using masking fluid. Note how the drawing is stronger towards the centre of the composition which accentuates the effect of the detail fading away towards the edges of the work.

Line and Wash: Working From A Photograph

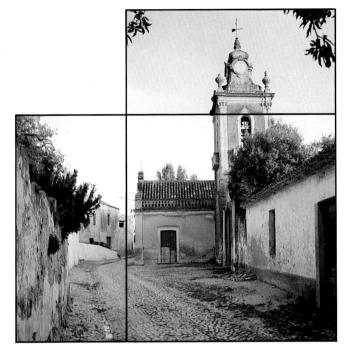

The diagram below (*top left*) indicates how skylight is blocked by upright objects such as buildings and trees, but is reflected off the ground. Although the actual or 'local' colour of an object and the direct sunlight on it can affect its tone, in general, the sky is the most powerful source of light and gives the lightest tones (see 1). This is followed by the reflected light from the ground while the darkest tones are found on those objects blocking the light (3).

The above points are illustrated by the tonal study below the diagram. Here another element comes into play. The further away an object is, the lighter in tone it seems. This is aerial perspective. Hence the distant building is lighter than those close by.

I drew the tower with exaggerated tones to indicate the dramatic effects that can be achieved using a technique known as 'counterchange' (*see page 66*). Note how the dark shadows of the tower are seen against a light sky and the sunlit areas against a dark cloud. In this way, maximum contrast is achieved between the edges of the building and the sky, which accentuates the effect of the sunlight. Look for this technique in other paintings and see how effective it can be.

'Sketchbook' Techniques

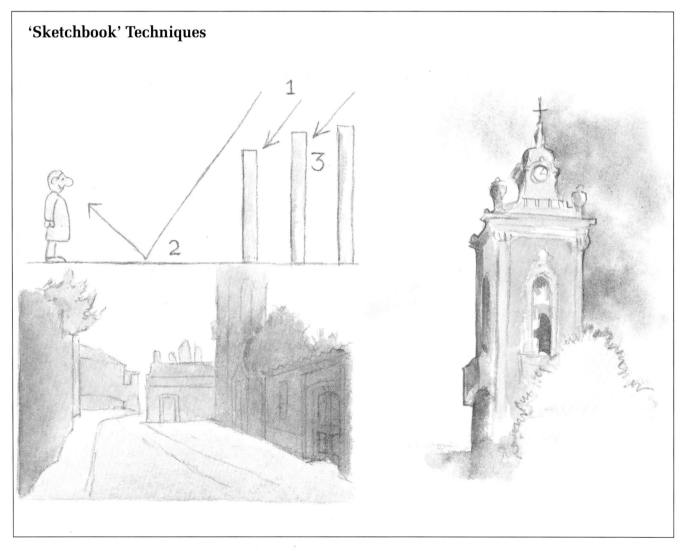

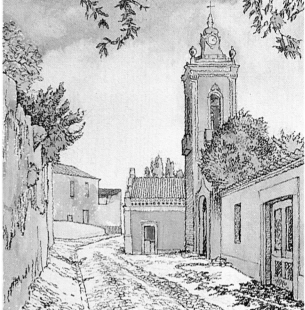

I am now well into the painting. I have mixed the fluid washes required for this technique in a deep-welled palette. I prefer the ceramic ones as they clean more easily than the plastic variety.

Warm and cool washes were laid smoothly across the buildings to suggest sunlight and shadow. The paint texture is kept to a minimum by using the side of my largest round brush. Some white paper, however, is allowed to sparkle through the colour. I always feel this gives the colour freshness when using line and wash.

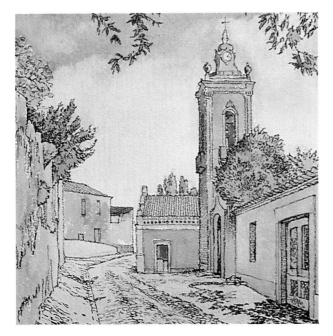

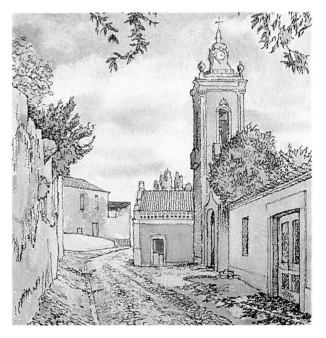

As the ground was in shadow it was painted with a blue graded wash. This is lighter in tone than the shadows on the buildings as the ground is reflecting light from the sky. The gradation from dark in the foreground to light in the distance gives a feeling of depth – aerial perspective. This completed the first layer of the painting with most of the masses blocked in with their highlight colour.

The possibilities of tone, volume and texture were now explored, beginning with a dull, purple shadow under the clouds. I chose this colour to contrast with the oranges of the sunlight on the buildings. Bright orange was scumbled over the blue of the cobbles. This warm colour will act as a foil to the green moss I planned to apply later.

(Continued on page 44)

Line and Wash: Working In The Field

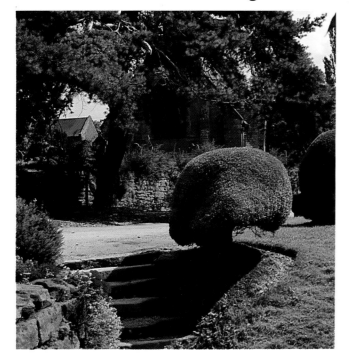

When painting outdoors the position of the horizon can be located, even when hidden by trees and buildings, by judging the level of your own eye (1). All parallel lines on buildings, brickwork, windows, gutters, etc., appear to converge to vanishing points 4 and 5 on this horizon. It is often confusing when faced with a complex situation such as this to know which parts of the building are converging towards which vanishing point. If you hold your hands up in front of you and angle them in the same direction as the surface you are judging, they will point in the direction of the vanishing point for this surface. Look at the two hands (3). The green one points to vanishing point 4 which is therefore the vanishing point for all the green surfaces of the building. The other hand points towards the edge of the paper (2) towards vanishing point 5 which is actually outside of the drawing. In this case there is no actual vanishing point on the paper towards which we can converge our lines, and the horizon must be employed to help us make our judgement.

You can see that vanishing point 5 is closer than 4 and that all the lines converging to the right are steeper than those converging on vanishing point 4, to the left. The angles at point A, however, are gentler than the angles at point B, no matter which vanishing point they converge towards. Look at the steps to the bottom left and you can see the reason for this. As the lines get closer to the horizon they flatten out. This is of great help when judging a line for which you do not have a vanishing point.

A final word, don't worry too much about perspective – it is the overall feel and quality of the painting that's important. You shouldn't use a ruler to indicate perspective; your line will become too rigid.

'Sketchbook' Techniques

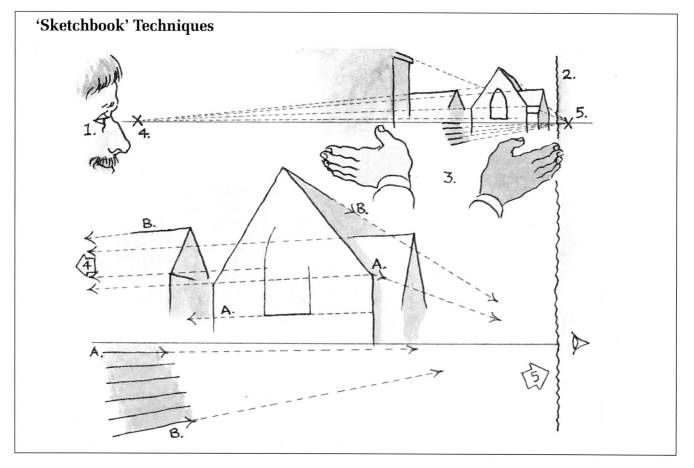

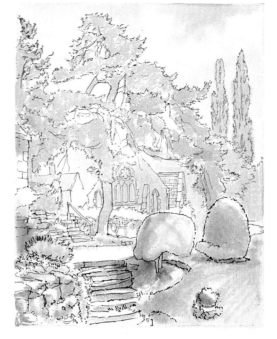

By a pure stroke of luck, the stone building in the left of the painting was a country inn so I was able to enjoy a glass of wine. This, of course, helped my creativity and was an excellent spot for attracting potential purchasers of the finished piece. *A votre santé!*

Washes of diluted Indian ink were applied throughout the picture, becoming increasingly dark towards the foreground. The sky was laid using a wet-on-wet, as opposed to a wet-on-dry, application over the large tree. My choice of technique was dictated by the different textures of the subject.

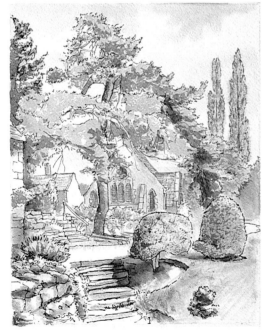

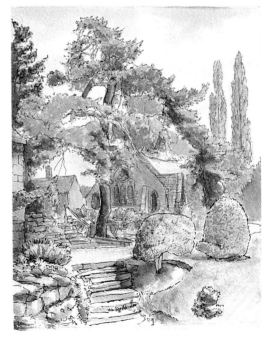

Scumbles of progressively darkening ink were applied across the painting. Some edges were lost to give a softer effect but, beware, Indian ink dries quickly and can overpower your linework. At this point, a passer-by made the following wonderful comment: 'You'd think that on a nice sunny day like this he'd paint in colour.'

Light washes of colour were applied over the top half of the painting. These were quite bright as the shadows were formed naturally by the grey ink washes underneath. This technique has obvious advantages for the beginner as colour mixing is kept to a minimum.

(Continued on page 46)

Line and Wash: *Artstrip*

It is easy to overwork a painting and you may even damage the paper surface. When I first started, I sometimes went right through the paper.

Don't worry, because everyone overworks when they are learning. It's better to overwork than to give up halfway.

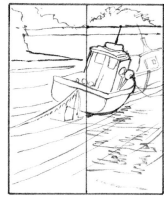

At this stage, you may decide to increase the linework. This can be strengthened by increasing line thickness, or broken by introducing overlaid opposing strokes.

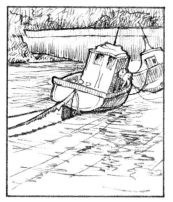

You could use cross-hatching to create texture, especially in shadow areas.

Alternatively, more irregular textures could be applied by splashing, spraying or sponging the ink on.

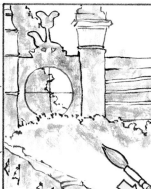

Pure colour washes can be textured by scumbling.

Hold brush flat against surface and drag the side of brush head across surface.

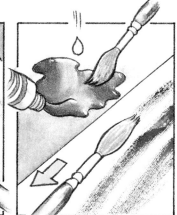

Brush is kept 'dry' by (a) adding a small amount of water to colour squeezed from tube so it remains thick. This mixture scumbles easily and gives a dark colour.

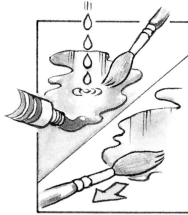

b) By adding more water you will lighten the colour but this very fluid colour mix will tend to flood painting surface . . .

. . . so any excess fluid has to be removed from brush on edge of palette or an absorbent tissue.

A light, dry brushmark can then be easily scumbled on to surface. Test scumble on spare paper before applying it to painting.

You can also use masking fluid to create scumbles which can be overpainted – an interesting technique to try out.

Removing masking fluid that has been scumbled over colour will give a light texture on a dark ground. Some colour lifts off with fluid, so you may have to adjust the wash.

For a different texture, take a white wax candle and carefully split it open lengthwise using a craft knife.

Remove wick and cut into small manageable lengths. Apply wax to surface as a resist.

These colourless marks are difficult to see until a wash is applied. If you look at them from the side against the light, the shiny reflection should reveal the waxed areas.

Note the difference between hard edge of masking-fluid resist (1) and softer, more diffuse edge of wax resist (2).

Either type can be softened by lifting off (*see wet on wet page 102*). Only work on a small area at a time.

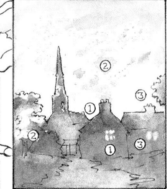

Here all three techniques have been used together: masking fluid (1), wax (2), lift off (3). Try a simple composition like this.

Ordinary wax crayons give a similar textured resist but marks are coloured.

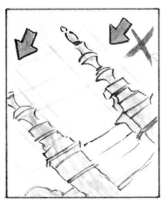

Any construction lines which have been painted over will be fixed by gum in watercolour. They will be especially noticeable under light areas such as the sky.

These lines are difficult to remove without removing colour as well.

So, always remove construction lines, or at least lighten them with a putty rubber, before applying colour, especially in lighter areas.

If you don't, you can strengthen colours to obliterate them but you may lose lightness and freshness associated with line and wash.

Line and Wash: Artstrip

Create highlights by scratching into surface with a sharp blade. Damaged paper will absorb additions of colour and, instead of a highlight, will be a dark accent.

A softer highlight or general paint lift can be achieved by sanding surface with fine sandpaper.

Overworking a wet surface can cause paper disintegration. You will feel surface friction increase and, if you continue, paper will begin to absorb excess colour.

You may see evidence of this damage as little balls of paper in the wash. If this happens stop immediately and allow paper to dry out.

If colour has been absorbed by paper fibres because of overworking, you may have to take out fibres in order to remove colour.

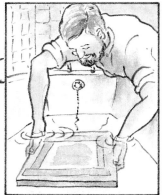

If you overwork a large area, immerse whole sheet in a bath of water – if you have not stretched your paper, do so immediately afterwards.

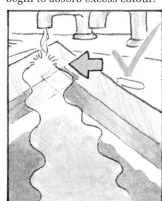

A smaller area of colour can be removed under running water. Make sure water does not fall directly on to paint as its force will lift colour indiscriminately.

Colour will not lift with either of these techniques until friction is gently applied to the surface with a brush. Lifted colour then floats harmlessly away.

Use a variety of brushes, for example, a hake, a flat nylon brush or a sable one to try out their different lifting abilities.

Allow work to dry thoroughly before removing it from board by cutting it away using a craft knife.

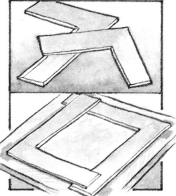

If paper sticks, don't pull at it or you may rip painting. Instead, gently release it by running a blunt kitchen knife underneath as if opening a letter.

Two 'L'-shaped pieces of card placed around your painting act as a visual guide to assess whether or not painting is finished, and often prevents overworking.

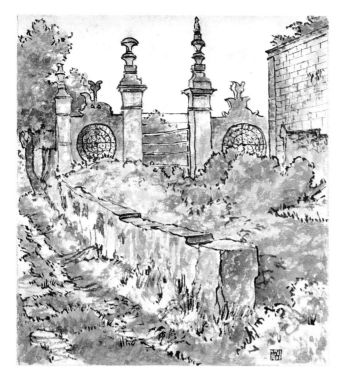

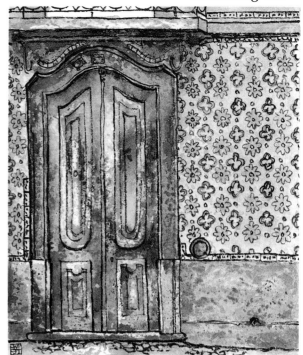

(*Above*) Scumbles and masking-fluid resists give texture to the stonework of this disused Portuguese gateway and the grasses surrounding it.

(*Above right*) The colour washes have been kept separate by applying layers of wax resist, creating a textured surface across the face of this typically distressed door in Portugal.

(*Right*) The colour from the lower section of this painting was 'lifted off' by placing it under a tap of running water. This was intentional and realising the degree to which paint can be removed will give you the confidence to apply it boldly in the first place.

Line and Wash: Working From A Photograph

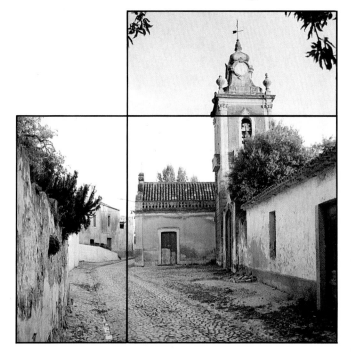

purple shadow to the yellow-green tree overlapping the tower, but, to match the yellow already present, I used a cadmium red in the purple mix. This use of warm colours to overlay greens is a valuable technique in all landscape painting. Moving on, I indicated the moss on the cobbles by using a yellow green in the distance and a warmer, red green (I added cadmium red) for the moss in the foreground.

(*Below right*) Light scumbles were applied across the surfaces of walls and buildings to suggest the textures of their worn surfaces. The direction of the brushmarks also gave form and volume. Again, these scumbles were mainly warm, contrasting with the cool and enriching warm areas. Note how the grey wall on the left is filled with colour by scumbling yellow orange over the blue purple. Mixed together, these colours would make grey, but mixed as layers the colours excite one another. Great care was taken at this stage not to overpower the line with texture, even in very dark areas such as the doorway to the right of the picture.

(*Opposite page*) It is easy to overwork a painting at this stage, but if you keep looking at the linework and remember that it must remain dominant, you shouldn't go wrong.

The final accents were applied to windows, gutters, tiles and across the ground. These accents are as important as highlights as they give contrast and thereby more sparkle to the colour. If they are applied with speed and fluidity you can avoid using them too heavily.

(*Below*) I now applied texture to the foliage in both warm and cool colours. For example, I added a bright purple (a mix of ultramarine and alizarin) as a shadow colour to the dark bush on the left. This not only acted as a contrast to the green but also warmed up the area to reflect the overall warmth of the painting. I also added a

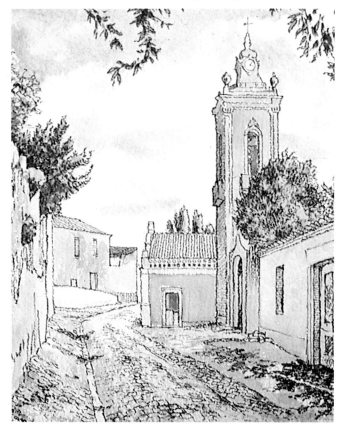

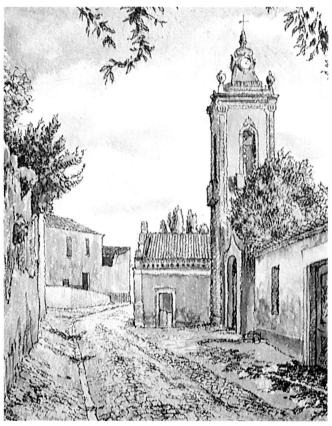

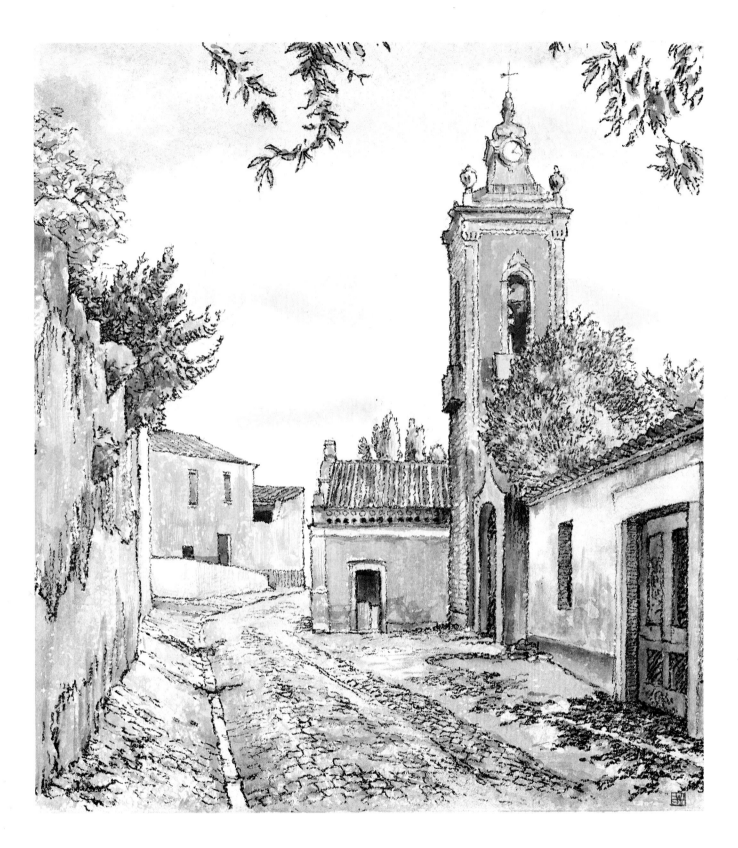

Line and Wash: Working In The Field

areas of the stone wall and buildings. These scumbles gave contrast and texture. To complement them, rich green scumbles were applied across many foliage areas.

(*Below right*) The linework was now selectively strengthened, especially against strong areas of colour. Cross-hatched shading creating texture, tone and volume was used where appropriate. In each case the silhouette of an object was approached first, only extending internal linework when that on the perimeter failed to produce enough definition or form.

(*Opposite page*) After a few days at home looking at this painting I was unhappy with some aspects. It just didn't have the vitality I wanted. I made a list of those areas requiring attention and, having worked my way through it, I stopped painting. In this way I prevented myself from overworking the piece and spoiling its freshness.

The areas I worked on were:

- The sky – this needed more contrast in blue and cloud shadow areas.
- Top of buildings – needed stronger line to give greater contrast against sky.
- Central tree – needed stronger line around it.
- Highlights – these were scratched out of church roof, hedge and foreground bushes.
- Green shadow areas – applied purple washes. This is one of my favourite tricks when a painting is looking too green, e.g., distant trees on the extreme right.

(*Below*) The washes were now applied to the bottom of the painting. The foreground area with its stronger line could take bolder colours. The pockets of flowers had been left as pure white paper up to this point and now bright scumbled colour applied across them suggested the detail and rhythm of the flowers.

Dark, warm, accent colours were added to the shadow

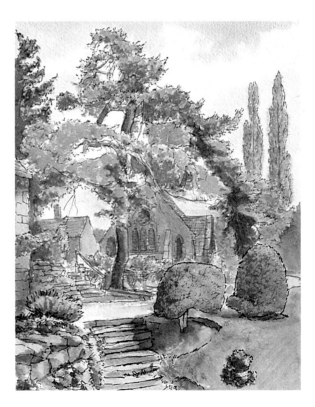

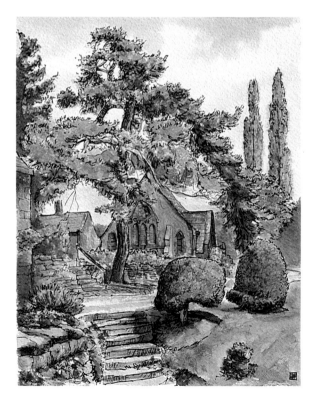

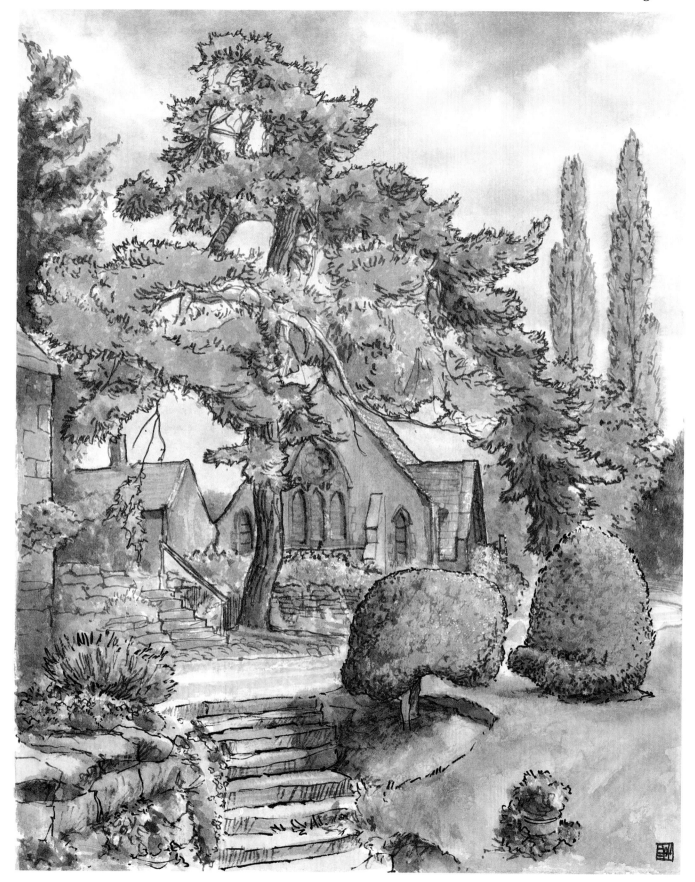

Looking at the painting a few days later I was content. If I hadn't been, I would have made another list and carried out the same process.

Line and Wash: Common Problems

PROBLEM The line here has become lost among the dark washes. While this is not technically a fault, you are leaving the realms of line and wash.

SOLUTION Depending on the wash strength, you can either strengthen up the line *(left)* or lift off some of the colour *(right)*.

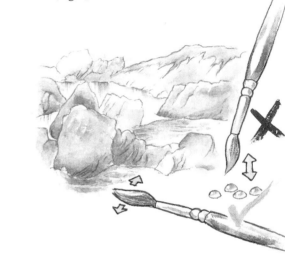

PROBLEM The internal paint edges have become so strong that they conflict with the linework causing a visually confusing picture.

SOLUTION To get round this problem you can: make the line stronger, or the colour weaker, or soften the edges with a damp brush. Remember not to dab the paint on – keep the brush on the surface and cover with sweeping strokes using the side of the brush head.

PROBLEM This problem often occurs at the start of a painting when the paper may seem reluctant to take the first wash. The size on the surface is preventing absorption of the colour – this effect is known as 'pigskinning'. You may like the broken quality this creates but your subject may require a more even distribution of colour.

SOLUTION Add a few drops of Ox Gall to your paint mixture – this is a wetting agent which reduces the surface tension and allows the paint to flow more evenly. Alternatively, you can wet the paper before applying any colour *(see wet on wet, page 92)*.

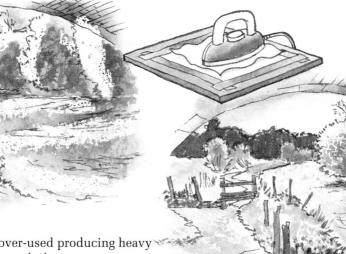

PROBLEM Wax has been over-used producing heavy worms of resist across the painting.

SOLUTION Practise on a similar surface before applying the wax to your work. Or, if the deed is done, you may be able to remove some of the wax with a hot iron and a paper tissue. To prevent the wax spreading further you need a constant supply of fresh tissues to iron over.

PROBLEM The over-use of masking fluid has created unsightly areas of solid resist.

SOLUTION Either (a) make sure you add a few drops of coloured ink to the masking fluid so that you can see exactly how much you are applying. Or (b), before layering the colour, gently rub off some of the masking fluid with a finger so the masked area is broken up rather than solid. And/or (c), once you have removed the masking fluid, scumble colour into the exposed areas.

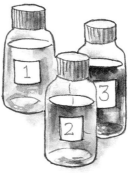

PROBLEM Diluting the ink required for diminishing line and tonal strength is messy and time-consuming, especially out of doors. You also have to spend time testing the washes as the diluted ink dries lighter.

SOLUTION Before going out in the field, prepare a quantity of ink solutions with gradually reducing strengths. Mix ink with distilled water as it stays in solution more effectively.

Wet on Dry

Using line and wash you have been able to explore the possibilities of colour and texture, while having the safety net of an outline to identify detail. Having gained confidence and experience with this technique, your use of colour will have become stronger and you may even feel that the line-work is no longer necessary. You are entering the realms of true watercolour. The structure of the painting is now controlled by the blocks of colour, rather than the line, whose edges give all the definition that is required.

When watercolour is applied to a dry surface it is known as wet on dry, whereby the brushmarks dry with a hard, clean edge, even when applied lightly. I look upon this technique as 'drawing with a brush' because of the clarity that can be achieved.

While control of the paint flow is absolute, it does not mean that you cannot be spontaneous and fresh. Indeed, there is an immense range of wet-on-dry styles, from an intense, illustrative approach to a more fluid, painterly one. To get the best from this technique you must become familiar with its characteristics and qualities.

Firstly, the paint flow, restricted by the dry edges of the brushmark, collects into a wall of colour, almost invisible to the naked eye, but of immense importance. A thin wash often gives a surprisingly dark edge in comparison to its strength. Try this for yourself. The following experiment will illustrate what a powerful effect this hard edge of colour can have. Paint two pools of colour and allow to dry. Now lift off the edge of one of the pools with a damp brush. You will be amazed how much lighter the remaining area will now seem as a result of losing its edge. Experiment and use this knowledge to your advantage.

I will describe in the following pages how these edges can be altered during painting and you should spend time experimenting so that you have the feel of the paint before attempting your first piece of work.

The second quality of the wet-on-dry brushmark is its clarity and strength which means it need no longer be subservient to an outline. The eye becomes more aware of the coloured areas which are now responsible

Wet on Dry

for carrying all the information about the subject. It is quite common to build up the paint in a series of layers directly on the paper. Mixing clean colours on the surface produces a vibrancy unobtainable if the colour is mixed on a palette.

On the other hand, dark palette mixes can be utilised and varied by applying them at different speeds and pressures, or with different brushes. The versatility of mark and texture is endless.

As a general rule, three layers of paint are normally sufficient for even the darkest of areas in your painting. You do have to apply the layers quite quickly in order not to lift off any underlying layers. Remember, freshness is of paramount importance in this technique, so don't be tempted to tickle. It is far more exciting to splash the colour around a little. You are not producing a photograph, so enjoy the natural effects of the paint.

Each piece of work should be an adventure. It should keep you on the edge of your seat and leave you exhausted, but fulfilled at the end, and remember, the key to a good painting is simplicity and suggestion.

For the beginner

No matter what your nature, there will be an aspect of wet on dry which will suit you. In the following pages I have tried to show several approaches. Personally, I prefer the looser approach as I feel that detail is less important than the quality of the paint.

However, if you are of a more illustrative nature then this technique also allows the most intimate of details to be recorded. A word of advice however: the cleanest coloured areas are produced when layers of paint are pure colour. In other words, if you combine colours for each layer you are much more likely to end up with a dull dirty colour. If you create your layers with unmixed colours, the resultant combinations will be vibrant. While it is not always possible, it is obviously better to keep the colour mixes simple when applying several layers.

52

In the field

This is a fast and exciting technique to use out of doors. Start getting used to working on an upright easel. It greatly simplifies the process of working from nature if your eyes can flick from subject to painting without moving your head up and down. Having to bend your back to work on a level board can also become extremely painful after a few hours.

Other artists

Observe other artists who work using wet on dry and decide which direction they have explored and why. Be critical as well as intoxicated by the work of others. You can learn a great deal from their triumphs and their failures. But remember too that no advance is ever made without taking chances. If you do not make mistakes you will never learn how to do things well, so be patient.

Roll of absorbent kitchen paper for lifting paint and general cleaning.

Plywood drawing board and good-quality watercolour paper – 200 gsm (90 lb) for experimentation and at least 300 gsm (140 lb) for your actual painting.

Gumstrip, 5 cm (2 in) wide for stretching thinner paper.

Small cup palette for masking fluid and small colour washes.

A deep-well palette in plastic or ceramic for large quantities of fluid washes which would run off a flatter surface.

(*From left to right*) 1 cm (⅜ in) nylon flat wash brush for painting and No. 6 round brush, No. 8 round brush, No. 10 round brush and an old toothbrush.

Two jam jars with lids for transporting water. I place a few drops of Ox Gall in the clean-water jar as it helps when applying colour washes to well-sized papers (*see page 91*).

Tubes of Artists' watercolours for covering large areas of wash and half pan colours for details: (*from left to right*) cadmium red, crimson red, ultramarine, Prussian blue, lemon yellow, cadmium yellow.

A kneadable putty rubber – to increase its flexibility warm the rubber by holding it in your palm for a few minutes.

An 0.5 mm automatic pencil (2B) – its fine line is easily covered with a wet-on-dry wash.

A natural sponge – small ones are useful for wetting the paper and creating textures.

Masking fluid for sharp detailed resists.

A few optional extras that you may wish to use: (*from left to right*) a white wax candle, wax crayons, watercolour pencils, phthalo blue Artists' watercolour (phthalocyanine), a useful extra colour for summer skies. So bright it's impossible to mix from your limited palette.

Wet on Dry: Materials and Preparation

There are a multitude of different *brush* shapes to choose from – I have selected those which I consider to be the most versatile. Spending your money on a good brush is a worthwhile investment as without the right tools you cannot hope to do yourself justice. It is natural when things go wrong to blame your lack of ability but you'd be surprised how much of it is down to poor equipment. I have often picked up one of my student's brushes when explaining to them how to achieve a particular effect. However, the lack of control offered by their soft, floppy, blunt brush has made it impossible for me to do so properly. So how do they expect to achieve a good result with this same brush?

The absolute necessities for wet on dry are two round sable or nylon brushes, essential for losing the hard edges of this technique (*see page 59*). You can get away with only one brush if your budget is tight, but ultimately this is a false economy. One brush should be kept for applying colour and the other kept for softening the brushmarks and should be kept wet at all times so the edges can be lost before they have a chance to dry out.

Another advantage of using two brushes is that it cuts down on waste as you don't have to rinse out the colour in your brush every time you wish to apply more water to the surface. This not only saves on the cost of your paint but also keeps your water cleaner and saves the frustration of having to constantly remix colours if you are only using them in small quantities.

In most circumstances I apply the colour with the smaller of the two brushes which means you can keep the larger one fairly dry. If you use too small a brush for losing edges there is a tendency to overload it with water in order to transfer enough to the paper surface. This has the unfortunate effect of causing backruns.

I have also mentioned in the list of materials on page 55 the use of watercolour pencils. These can be used in any area of watercolour painting. However, their method of application is so similar to that of the wet-on-dry technique (each layer is softened with a damp brush before another one is applied) that it is a good idea to experiment with them at this stage.

When you buy a brush, its head will be protected by a transparent sheath. Keep this and every time you use your brush replace the covering. If you lose it you can make a new one with rolled paper or a straw cut to the right length. Never allow paint to dry in your brush and never leave it point down in a water jar or the hairs will distort. Always finish a painting session by cleaning your brush with soap and cold water. Hot water will expand the ferrule (the metal ring) and melt the glue holding the hairs in place. If the hairs do become distorted or bent through bad storage, work the head across a bar of soap until it becomes stiff. You can now shape the brush to a point with your fingers and leave it for a few days to dry in the brush. Finally, lay the brush in a sink of cold water until the soap softens naturally. The brush should now have regained some semblance of its former glory.

Soap can also be used to protect your brush when applying masking fluid. Many people use an old worn brush for this purpose because they are afraid the fluid will dry in the brush. You are, however, trying to create sharp highlights and focal points with the masking fluid and to do this with a tatty old brush is totally illogical. Instead, try wetting and working some soap into a good brush before dipping it into the masking fluid. If you have a large area to cover and you feel the fluid hardening in the brush, then, simply clean it and go through this process again.

With regard to the paints, you can use Students' quality while learning the basic techniques although generally I would advise buying Artists' quality paints. The latter are made from pigments as opposed to the former which are made from dyes.

If a pigment is difficult to obtain or the raw material from which it is derived is very expensive, then it will be very costly to buy. True ultramarine, for example, is made from the semi-precious stone, lapis lazuli. You can still obtain this from the manufacturers, but you will have to pay for the pleasure of painting with a semi-precious pigment and I very much doubt if you would notice the difference between that and French ultramarine.

Within the Artists' quality range, the price of the paints will differ widely. Be careful and note the series number of any paint before you buy it as the price will vary accordingly. I have found that you can find most colours to suit your needs within the lower price ranges. The cadmiums, for example, are expensive so go for a cheaper, similar colour. When doing so always check on a colour chart that the particular colour you choose is permanent when exposed to light. The colours are usually given a star rating on the chart as a guide to their light fastness.

One great advantage of Artists' quality over Students' quality paints is that they are so easy to dissolve, even when dry. This makes them far more economical than they at first seem. Students' quality colours, when dry, may as well be thrown away especially when you consider the time wasted and the damage inflicted on your precious brushes, trying to re-dissolve them.

My palette has heaps of dried Artists' quality colour on it. Ten minutes before a painting session I wet these either with a brush or by laying a wet cloth over them. This softens the paint and allows me to keep re-using the tube colour and avoid the waste I used to incur with Students' quality paints.

When buying round brushes, look for natural pointing and spring when wet.

These brushes, especially the larger sizes, are versatile as you can achieve both detail and line with their point. . .

. . . and larger flat washes using the side of the brush head.

Flat nylon brushes can be used for laying washes or lifting off any dry paint.

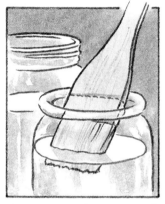

The water jars, for mixing and cleaning, should be wide enough to take your largest hake with ease to avoid damaging this soft brush.

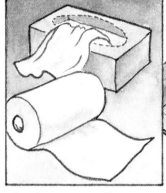

Absorbent paper rolls or tissues are essential – cloth will not absorb as speedily or effectively and will tend to smear the paint.

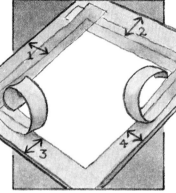

Your drawing board should be 5 cm (2 in) wider on each side than your largest paper size to allow for gumstrip when stretching. 1=2=3=4=5 cm (2 in)

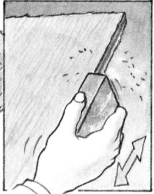

It should have a natural finish to allow gumstrip to grip and paper to dry evenly. If you make it from 2 cm (¾ in) plywood, sand the edges to avoid splinters.

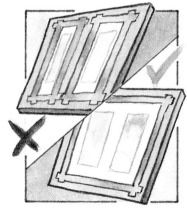

Never stretch two pieces on the board. If you do and re-use it to stretch a larger piece, it may stick to leftover gum in centre of board.

You can work either at a gentle angle or, using a table easel, at a more acute angle.

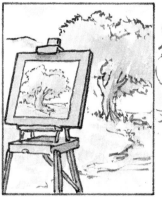

Or, by far my favourite, upright at a standing easel with the subject to one side.

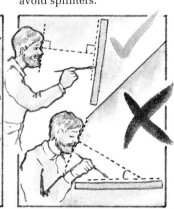

The upright angle enables you to view the proportions correctly. If you work flat the images will be distorted.

Wet on Dry: Artstrip

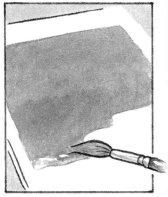

Painting a smooth area of colour is known as laying down a flat wash.

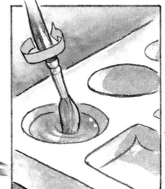

Mix sufficient paint to cover all of desired area. Stir well.

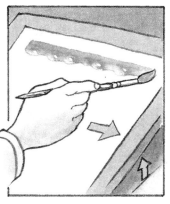

Tilt board and, with a fully loaded brush, lay a band of colour across top of paper.

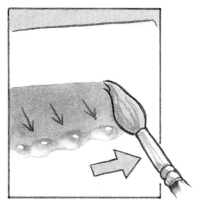

Keep brush in contact with surface. A pool of colour should form along bottom which slows drying of this edge.

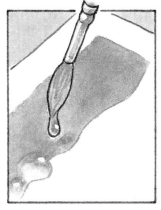

If a pool does not form, drop more paint on to wet edge.

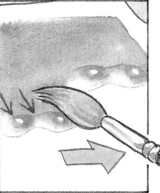

Recharge brush and lay second band under first. First pool will then run down and collect along lower edge of second paint line.

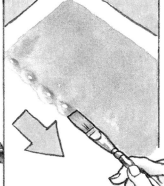

A flat brush could be used here. Note change of brush angle to paint edge.

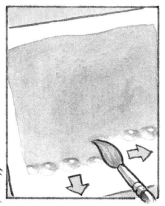

Continue down ensuring pool forms each time you lay a band of colour so an even flat wash is produced.

At base of area, squeeze brush in a tissue or flick brush head vigorously so most of fluid is removed. This damp 'thirsty' brush can now be used to lift off any excess pooling.

While wash is wet don't be tempted to try to correct small imperfections. It's safer to let it dry before repairing.

For a different approach, repeat technique adding a touch of a second colour to mix at each level. Always mix well and apply to create a graded colour wash.

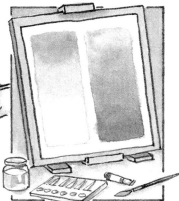

Adding water or additional pigment of the same colour either lightens or darkens the wash gradation.

 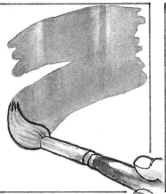 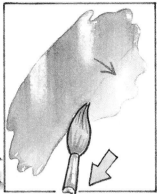

With a well-loaded brush you can produce an area of evenly laid colour by keeping brush head in contact with surface when applying wash.

Every time surface contact is lost a small pool of colour forms. If this is repeated with a dabbing motion, an uneven, dirty, textured finish will result.

While the normal wet-on-dry brushmark is distinguished by its hard edges. . .

. . .these can be softened or lost while still wet by running a damp brush along their outer edge.

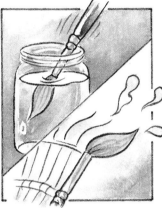 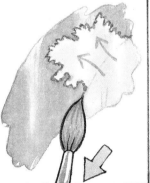 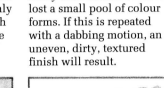

It takes practice to get water content of brush correct to match that of the surface. As a rough guide, after dunking, a soft flick of the brush should remove the correct amount.

If brush is too wet, excess water will flow into coloured area pushing pigment ahead of it.

This wall of pigment dries to a dark, hard edge and creates the easily recognised texture known as a backrun.

Although technically regarded as a fault, they can be used creatively, for example, rock textures can be shown using this technique.

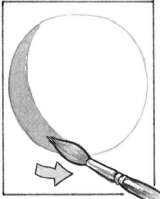 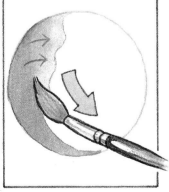 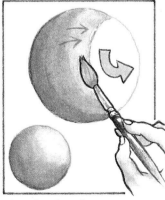

Lightly draw a circle, using a pencil, on your watercolour paper and paint a crescent of colour within it.

Lose inner edge by running a damp brush along it.

Clean brush and repeat process, eventually producing a sphere of colour without any internal hard edges.

If the internal edges dry too quickly, try exercise again, but this time damp the inside of the circle with water.

Wet on Dry: Artstrip

Draw a skyline lightly across your paper with a 2B pencil. Make it as interesting and irregular as you can.

Invert your drawing. Mix a strong colour for the sky. Make another mix with lots of water and only a few drops of the colour. Apply paint at horizon using the lighter mix.

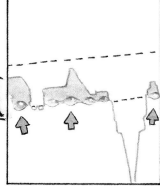

Imagine you are painting a straight band of colour only parts of which you can see between the buildings. Allow pools to develop along bottom edge of paint.

Add a drop more colour to the thin mix and stir well with brush – ensure colour is mixed in brush head as well as in palette.

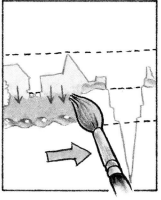

Paint next band of darker colour beneath the first.

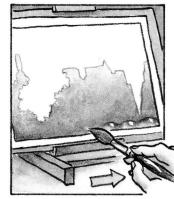

Continue in this manner until a graduated sky is produced. Finally remove pool at bottom with a 'thirsty' brush.

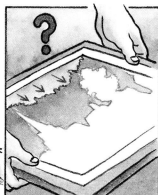

Lie board flat for next stage, being careful not to tilt it downwards as this could cause backruns from the top.

Dab the still-wet wash with tissue to create a cloudlike effect.

If wash has dried, slightly dampen it with a wet brush and then dab with tissue.

General hints – keep first washes as even and untextured as possible by painting with side of a large brush, always keeping it in contact with surface.

If you simply fill in between pencil lines your painting will become static with heavy brushstrokes.

Brushmark fluidity is more important than accuracy. This is a painting not a photograph, so feel free and buoyant with first light washes (*see opposite page*).

Have a go at painting these shapes using one colour only. Note the use of a technique called counterchange whereby the maximum contrast of tone is achieved at the edges of a subject (i.e., light edges have a dark background and vice versa). In addition, look at the intentional use of backruns on the ivy leaves.

This is an exercise in colour gradation and mixing by layers. The vertical areas were painted first and the horizontal bars laid over them. It is by no means an exhaustive chart, but will give you a feel for the colours that can be produced. It is interesting to note what a difference it makes when the same two colours are mixed but change positions, for example, blue laid over yellow looks quite different from yellow over blue.

You can see here what can be achieved by applying simple graded washes. The sky was first laid with an orange wash. This was unusually dark towards the horizon giving the effect of light behind the cloud. The brushstrokes are broad and simple – an essential quality when overlaying complementary colours such as blue and orange. If they mix through overworking they will become dirty. Note the 'pigskin' *(see page 63)* effect of the paper in the dominant cloud formation. Useful here to depict shimmering light.

Wet on Dry: Working From A Photograph

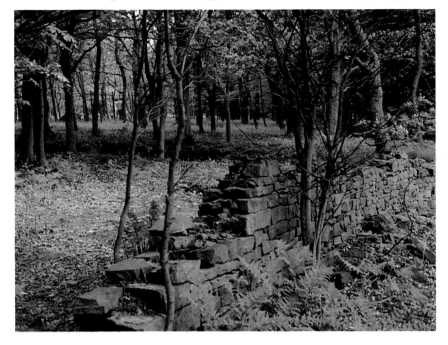

I was attracted to this view by the wonderful bluebells and the texture of the broken wall. The photograph, not unusually, is disappointing. Flowers *en masse* often lose their intensity and don't seem as impressive when condensed down to the scale of a snapshot. In this case it would have helped if a larger proportion of the picture surface was dedicated to them. I thought of adding a figure or deer just behind and to the left of the wall. This idea may appeal to you but do make sure you have a good reference shot for any additions and do more thumbnails to see how the idea can be exploited, and if it will improve or destroy the composition.

The changes in the thumbnails shown below are quite subtle but no less important for that. Even the final choice doesn't seem that far removed from the photograph. Study the changes carefully and see if you agree or disagree with my decision. Perhaps you could draw some different thumbnails and suggest an alternative approach – it would be just as valid as mine.

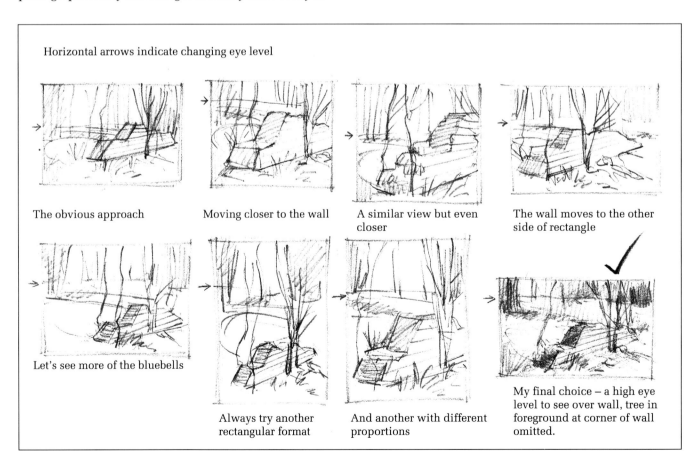

Horizontal arrows indicate changing eye level

The obvious approach

Moving closer to the wall

A similar view but even closer

The wall moves to the other side of rectangle

Let's see more of the bluebells

Always try another rectangular format

And another with different proportions

My final choice – a high eye level to see over wall, tree in foreground at corner of wall omitted.

The proportions of the chosen thumbnail were carefully transferred to the watercolour paper. The line strength here and in the following step is much stronger than it should be so that you can see it on the page. The correct line strength is shown in step 3 *(bottom)*.

Further detail was then drawn into this grid.

(Above) Having laid the first washes, I am able to see the compositional balance as it will appear in the finished piece. My last chance to make major alterations.

Use the largest round brush you have to block on these very thin base colours. As you work, keep the brush on the surface as much as possible to keep colour even and untextured. Pigskinning may occur if your paper is heavily sized and partially rejects the paint. The sparkling white of this phenomenon can be exploited (see bluebell area). Once you have covered the majority of the surface with a thin layer of colour, the gum in the paint makes this pigskinning less likely to occur with subsequent layers.

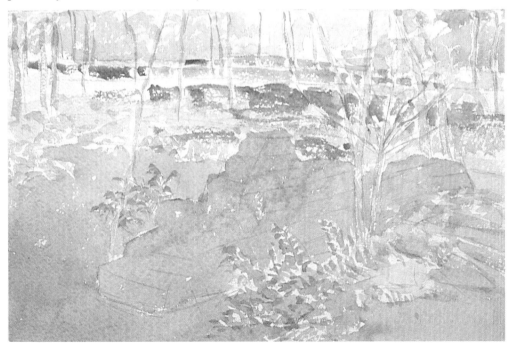

(Continued on page 70) 63

Wet on Dry: Working In The Field

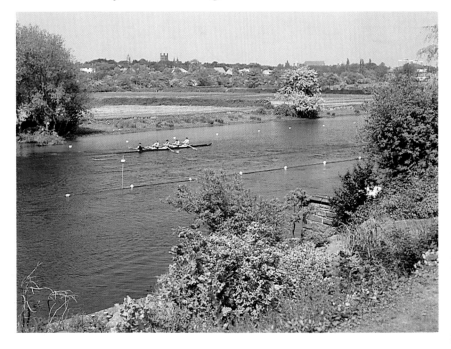

Some friends were kind enough to invite me to their riverside garden to paint this picture on Chester Regatta day. It was unusually hot and all day long boats were racing past. In the distance the cathedral could be seen against the skyline and across the river was a meadow full of flowers. I wanted to capture the essence of the day as well as show this attractive and unusually steep garden, which, from where I was standing, looked as if it tumbled down the hill straight into the river.

The fact that the racing boats appeared every few minutes meant that I could capture them. Under normal circumstances a boat passing by would have been too fleeting to portray.

This river could have proved too strong a diagonal element for the composition but I was able to contain it by including the trees on the far left and right, and the poppies in the foreground.

A view looking up the river which I rejected.

My high viewpoint demanded a high eye level, but in this thumbnail it had become too horizontal.

A change of format with slightly different eye levels. I also changed my mind about the foreground content here.

Perfect – so off we go. . .

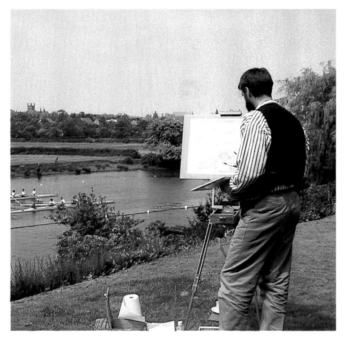

Here I am, all set up and getting into the painting. You can see now how I've used a little artistic licence with the proportions, for example, look at the size of the cathedral and don't you think the skyline on the photograph looks a little flat? This would be a problem for the photographer but not so for the artist who can take a creative gambit.

I transferred the main silhouettes from my chosen thumbnail. The greyish-green marks are masking fluid applied to protect those areas which need to stand out, but are too difficult to paint around, for example, the bright red poppies and the boats. I have also used scumbles of resist to suggest the yellow buttercup fields.

Broad, smooth washes were laid on with a large round brush to establish principal masses. This was the last chance to change the composition and standing back from it I was happy with the balance.

Normally I would have started the next stage from the top of the painting, but as I wanted to spend as much time as possible painting the boats I decided to tackle the water first. I started with the reflections of the two large trees on the far bank.

(Continued on page 72) 65

Wet on Dry: Artstrip

Painting a tree – note how the leaves grow in irregularly spaced masses or 'platforms'. Variations in spacing between these platforms characterises different tree species. . .

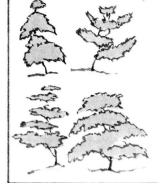

. . . as does its overall shape. Sketch from nature to familiarise yourself with these characteristics.

Sketch in platforms lightly with a 0.5 mm automatic pencil. Note relative thickness of trunk and its irregular positioning against leaf platforms.

Form platform silhouettes using side of brush head for an even thickness of paint. Note natural pigskin effect has been retained to suggest texture of leaves *en masse*.

Break up platform edges of silhouettes to suggest individual leaves by scumbling or dabbing.

When dry, lightly paint in branches and trunk with a warm colour using point of brush.

Add a darker layer to lower sections of platforms, on right of tree, indicating shadow areas.

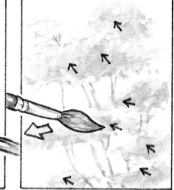

'Lose' some edges of these darker areas with a damp brush.

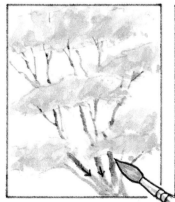

Dark, cool shadows and texture can now be scumbled on to trunk and branches.

Using a large brush apply a background wash around lighter side of tree – this gives definition and contrast.

On the darker side of the tree this wash can become much lighter. This changing balance of contrast on either side of the tree is known as counterchange.

A scumbled wash is dragged on for grasses and while still wet a wash of cooler colour applied to indicate tree's shadow.

Painting a flower – analyse structure of flower head and rhythm of foliage. Lightly pencil in outline made from your observations.

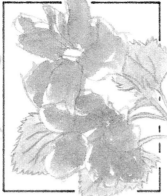

Apply first layer of colour which will eventually form the highlights. Keep brush on surface to achieve a loose fluid quality.

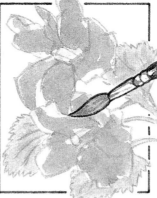

Allow to dry and then mask highlights on flowers and leaves with masking fluid.

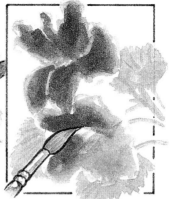

When dry apply shadows to the flower heads. Never use complementary colour mixes for flowers – the result is too dull. Just add more of same pigment or of a similar hue.

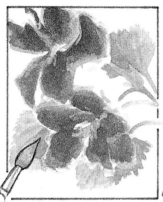

Carefully apply shadows to leaves.

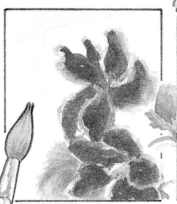

Using a large brush block in main background areas using a light wash or colour. . .

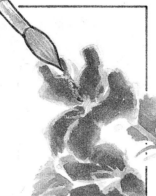

. . . and while still wet carry this colour between flowers and leaves with point of brush.

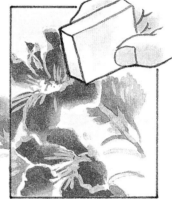

Allow to dry and lift off masking fluid using a putty rubber.

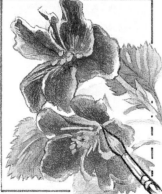

Add final linework to focal points and lose where necessary.

Painting rocks – gently draw in the shape of a group of rocks.

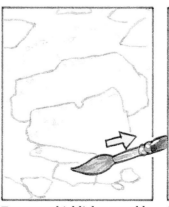

To protect highlights scumble masking fluid along top of rock edges. Selectively scumble mask *(top)* between large rocks to suggest light catching smaller stones.

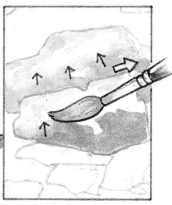

Loosely block in shadows across lower sections of rocks and background. 'Lose' shadows gradually, particularly towards top edge of rocks.

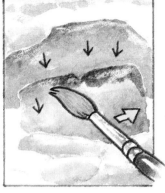

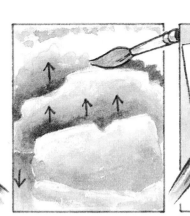

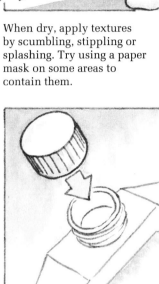

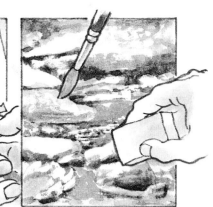

Along top edge of rocks apply an irregular band of colour. Blend it downwards.

Or place colour above rock and lose into the background. Both methods increase contrast, but this 'negative painting' highlights rather than darkens top of rock.

When dry, apply textures by scumbling, stippling or splashing. Try using a paper mask on some areas to contain them.

Remove masking fluid with putty rubber and where necessary drop colour into exposed white areas.

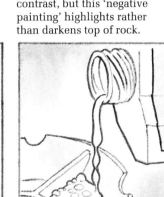

Masking fluid – always shake well before use. Whether in its natural form or with added pigment, it tends to settle and, at the top, may solidify with air contact.

Shaking will make solution frothy, so pour small quantity into a palette and allow to settle.

Always replace cap on bottle immediately to prevent bulk of fluid drying out.

Never allow masking fluid to mix with wet paint. It coagulates and both brush and wash become clogged with rubber strands.

Never paint masking fluid on to a wet or damp surface. It infiltrates the fibres of your paper and cannot subsequently be removed.

Ensure paint covering masked areas is dry before removing mask as it could smear if removed too early. If paper is still damp it may tear with removal of mask (*bottom*).

Don't leave masking fluid on paper for more than a day. The longer it is on the more difficult it is to remove.

Masking fluid deteriorates in bottle and if too old is difficult to remove once applied. If in doubt, dispose of it and buy new.

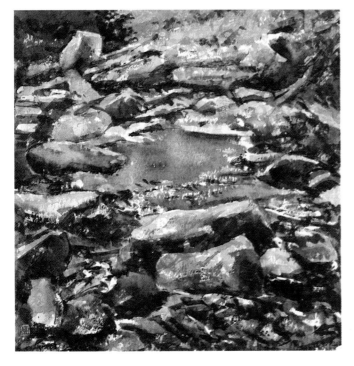

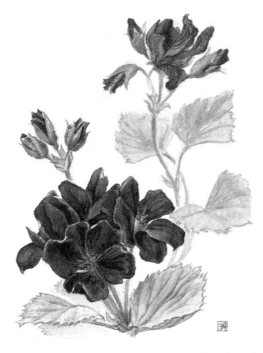

Note the fluidity of the brushmarks in this study, only suggesting detail. A dark painting such as this can easily end up overworked, so be bold and keep to three layers only. I laid warm colours over cool, and vice versa. To make the layering exciting, the highlights were masked and later, when revealed, were scumbled with bright colour.

The detail on the lower flower is very tight. This shows how wet on dry can be utilised in a meticulous way to render every nuance of a subject. A plant illustrator may choose to show every stigma and stamen, resulting in a highly detailed study. You may decide, however, to be a little looser and go for the feel and rhythm of the plant's structure, only hinting at detail.

I used many greens in this study, utilising the full range from blue green to yellow green. The addition of reds, especially cadmium red, resulted in some wonderful grey-greens, which introduced an extra dimension. The inclusion of a bright red splash of azaleas behind the trunk of the main tree on the left created a stunning contrast of complementary colour. If they had not been present I might have been tempted to introduce them as a splash of red can often make surrounding greens appear even greener – an old Constable trick. To create the tiny sparkles of light on the water the paint was scratched off using a scalpel.

Wet on Dry: Working From A Photograph

The page below indicates the importance of directional brushmarks in creating both movement and structure in painting.

Using our composition I have tried to depict the main direction in which the paint has been applied (see diagram 1). By removing colour, tone and texture from the marks and making their application as even as possible, you can see the importance of the pattern alone in creating form. I tried this same experiment (see diagram 2) but applied the paint to a wet surface thus eliminating the edges of the applied marks.

Experiment by continuously changing the direction of your paint application. This painterly approach is preferable to a static photographic one.

'Sketchbook' Techniques

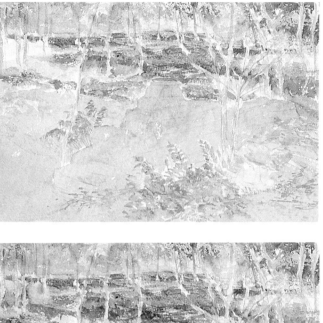

Lifting off the masking fluid. Great care is taken not to damage the paper. My left hand is feeling for unseen areas of dry fluid.

(Above right) Masking fluid was applied to the wall and foliage areas, but most especially to the bluebells. As usual, the application of colour began at the top of the painting, with the tree foliage, avoiding the tree trunks. A bright purple wash was placed over the bluebell area. It is very important with flowers that even their darkest shadows should remain bright in colour and so I avoid using complementary mixes which tend to dull the colour. Foliage was painted in warm and cool greens losing edges to give variety to the brushmarks.

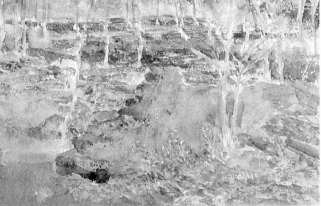

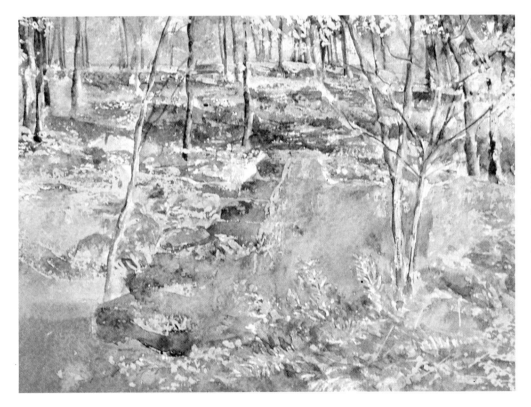

(Above) Large, warm brown brushstokes were laid across the forest floor giving structure and texture to the surface. Note how the hard edges of this colour give definition, and the lost edges suggest rounded form. This colour is mixed more intensely than the photograph suggests, as it was the perfect complementary to the blue of the flowers. The wall is a mixture of the two colours and acts as a stabilising factor in the colour balance of the picture.
(Left) Cooler greens were now introduced to the tree foliage and the tree trunks. This green was intentionally cooled (by making it become bluer) as it moves away from us. The masking fluid was now removed, thus completing the second layer.

(Continued on page 78)　　71

Wet on Dry: Working In The Field

The 'sketchbook' page below shows: (*top left*) the layers involved in creating the buttercup meadow. First an area was masked with greyish-green masking fluid. Once removed, the white areas revealed were painted with a bright yellow to denote flowers. Finally a yellow green was scrumbled all over to break up the mask. (*Bottom left*) this is an enlarged detail of the wall located in the right of the foreground. The orange undercolour used in the painting has been omitted to show the purple-grey shadow and the warm line wash. (*Right*) the three stages in painting the skyline. Firstly, the silhouette was rendered in a warm grey. When dried, it was too neutral so I overpainted it with bright warm and cool colours. Finally, blue accents were added to suggest shadow and distance.

'Sketchbook' Techniques

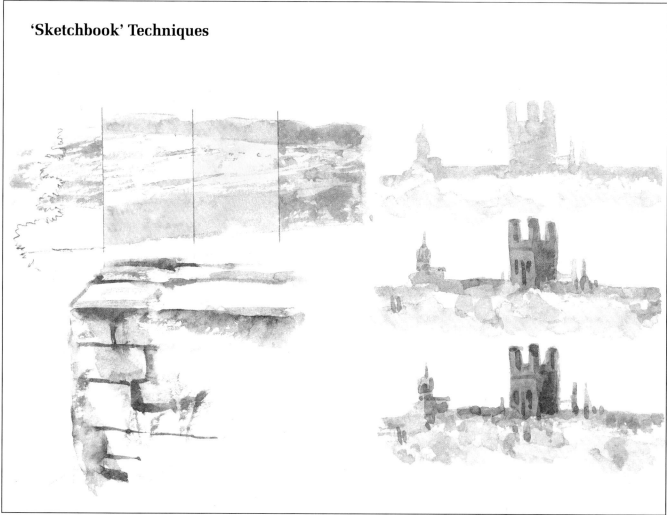

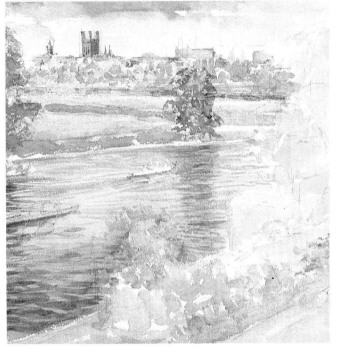

As the day progressed the colours became warmer. The painting is beginning to take shape and I was beginning to feel confident. Although it is very tiring and demands great concentration, there is nothing to beat painting out of doors in good weather like I had that day. You will learn more in a day working outside about colour and light than you will in a month working in a studio from photographs.

By applying light, bright, warm and cool colours, I brought some broad areas of definition and texture to the distant buildings and trees. The contrast of tone between these areas and the background began to suggest the fall of light.

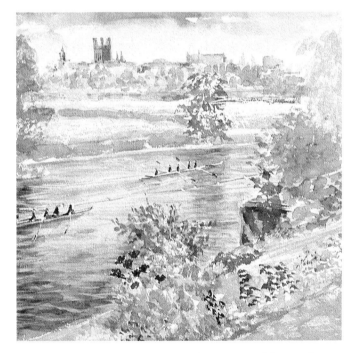

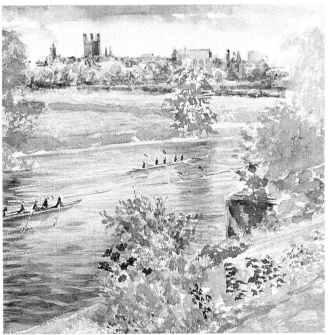

I removed the masking fluid with a putty rubber and applied bright colours for the boats, poppies and foreground flowers. The trees and wall, to the right of the foreground, now received some scumbled textures, some of which were lost.

I laid a bright cadmium yellow across the buttercup meadows while the buildings and trees received cool accents in shadow areas, increasing the feeling and intensity of the light.

(Continued on page 80)

Wet on Dry: Artstrip

If the first washes are laid thinly and evenly to establish general silhouettes. . .

. . .the second layer can break up these large masses by overlaying colour of differing hues.

Finish off by establishing dark accents of colour which act as a foil to lighter areas.

Limit number of layers to three, or under, and colours remain clean. Beyond that number, colours become sullied and overworked.

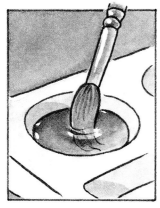

Finishing accents
Pooling – mix a reasonably fluid, yet dark wash of colour.

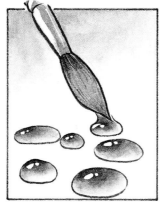

Drop pools of this on to a piece of watercolour paper and allow to dry.

These pools will dry with a dark 'wall' of colour around their edges which gives them a jewel-like quality.

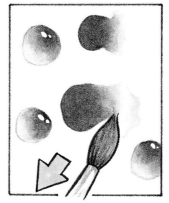

Not only are these accents attractive if left to dry naturally, but while wet their depth allows for the lost-edge technique to be employed with ease.

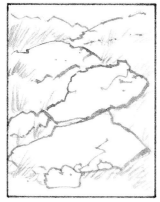

Lines of colour – if left to dry, accent will be too heavy and will look like line and wash. Lines are shown here, without any underlying colour.

Line, therefore, should be lost either down its edge or at one or both ends.

In the top example, the line is lost into the rock and suggests volume. In the lower one the line is lost into the background and suggests light.

Employing a variety of line thicknesses brings excitement as in line and wash.

Textures
a) *Scumbles* – these are accents which also suggest form as they create directional texture.

Try holding brush overhand to present a greater surface area of brush to paper.

This also allows more freedom of movement and brush can be drawn in direction of required brushmark.

Try scumbling with different types of brush. round sable *(top)*, flat nylon *(middle)*, oil-painter's bristle brush *(bottom)*.

 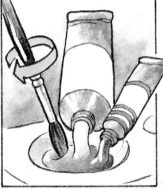 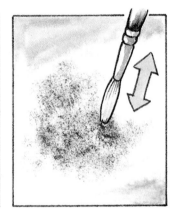

Scumbles here are expressing form and creating accents.

Aquapasto, a thick painting medium, is useful for mixing with paint to create a buttery consistency. . .

. . .this makes dry scumbling with light tones of colour much easier.

b) Also try *stippling* on paint with a stiff brush such as an oil-painter's bristle brush. Try this with and without aquapasto.

c) Colour can also be *splashed* (top) or *sprayed* on.

d) *Sponging* – An artist's sponge provides wonderful, natural textures. Each sponge will be slightly different.

Don't forget that if you want to lose these textures, simply apply a damp brush before they dry.

e) *Knifing out* – lay down a wash of medium-dark colour. Allow to settle but not to dry.

Wet on Dry: Artstrip

Take a blunt kitchen knife and, holding it nearly flat to surface, press blade into wash and pull. Be careful not to cut or tear the surface.

This will squeeze colour away from surface. If wash area is too wet the knifed-out area will fill in, if too dry the colour won't move.

This unique quality of mark is used here for trunks, water's edge and bridge.

f) Sgraffito – you can also use end of brush for technique just described. If paint is squeezed out as paint is drying, white lines will result.

However, if paint is still wet the paper surface will be damaged and will absorb the pigment resulting in dark lines.

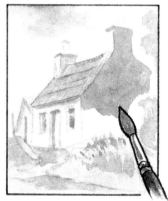

g) Restricted wet on wet – paint a thin wash of colour, on a dry surface, over the whole of required area. . .

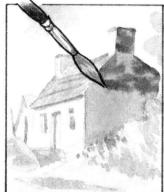

. . .and then drop a darker hue on to this thin wash before it dries.

The outer edges of the area are, therefore, hard edges, while the internal brushmarks are soft.

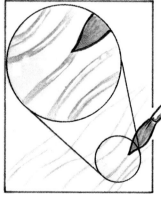

A similar effect can be achieved with line by first drawing deep fluid lines of thin colour, or water, using a medium-thick, fine-pointed round brush. . .

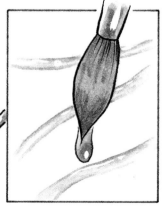

. . .and then, using a well-loaded brush, dropping liquid colour into the lines.

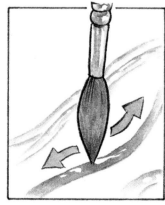

The pigment races along the wet lines, dissipating colour as it mixes with the water.

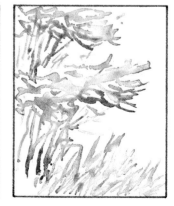

Use your imagination to think of how you could employ this technique.

The first layer of this study contained as many examples of restricted or contained wet on wet as I could manage. This produced a painting with many areas of soft tones requiring the minimum of 'accents' to finish them off.

The subject matter here proved perfect for practising scumbling techniques. Notice how warm colours are scumbled over cool ones and vice versa. This produces an exciting textural paint surface even on such a dark subject as this blasted tree.

This is Arthur, who is always trying to attract my attention. Notice the areas of restricted wet on wet across his body and the scumbles to suggest fur. His face and the telephone dial are shown in more detail than any other part of the study which draws attention to them. The background and repetitive patterns on the basket are simplified so they don't dominate and the colour in non-essential areas is reduced in intensity. Fine lines such as the whiskers and eye highlight were achieved by using masking fluid.

Wet on Dry: Working From A Photograph

(Below) Areas of wax resist, using a candle, were applied to the wall and forest floor. A cooler, darker brown was now applied as accents to the latter. The direction of these textures is of the utmost importance. If you work your eye in a clockwise direction around the bottom half of the painting and take note of the direction of these forms, you will see that they generally lead the eye towards the wall, which is, of course, the focal point of the painting. An artist such as Van Gogh leads you around a painting by the directions of his brushstrokes.

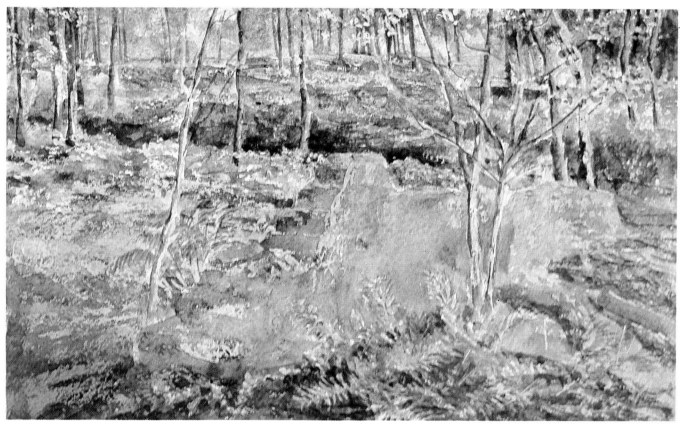

(Opposite page, below) I lifted off some of the left-hand edge of the wall which had become too solidly dark. I then introduced some strong cool orange browns across the forest floor in the immediate foreground, giving contrast to the cool colours in the wall and foliage. Linework and shadows were applied speedily and fluidly to the trees, becoming cooler in the distance, with the point of the No. 8 round brush. The trees in the foreground were given a warm scumble to pull them forward and give them texture. Note again how these trees lean inward towards the centre of the painting, framing the centre of the picture to focus the eye.

(Below) Scumbles of warm and cool colours were applied across the wall's surface, enhancing its texture, and linework applied to suggest individual stones. To make this look more natural, the linework was occasionally lost with a damp brush. More shadow colour was applied to the left-hand edge of the wall to give volume and strength to individual stones which were working loose from the main structure. The fallen stones to the bottom right of the wall were given the same treatment, enhancing further the eye's movement towards it. The wall was now strongly dark against light on the left-hand side and to provide a little counterchange (light against dark), a dark green was applied above the wall on the right which was then lost in the background vegetation.

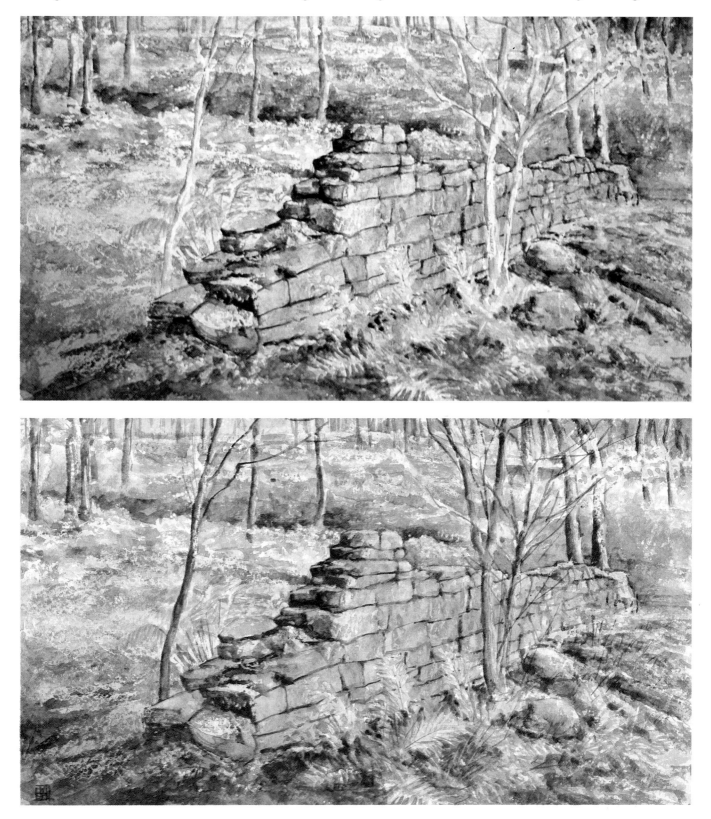

Wet on Dry: Working In The Field

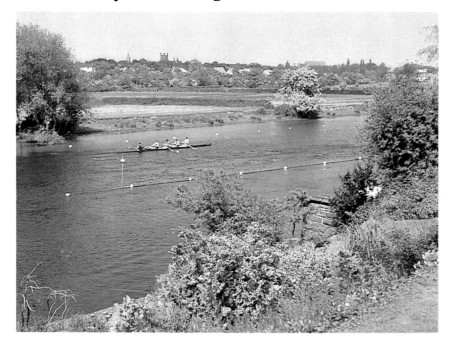

(Below left) To break up the slabs of colour and to suggest the texture of the flowers, I scumbled a light yellow green across the meadow area. The hedges and distant bank of the river were overlaid with a grey green and the white highlight in the central tree laid with a light dull orange. Dark accents of shadow were laid down the right-hand side of this tree and the one to the far left. Using the lightest of touches, I also suggested the branches that could be glimpsed between the leaf platforms of the latter tree. A dark line under the boats gave them more definition among the water textures. The willow to the far right of the near bank received some darker green textures to suggest its rhythm and movement.

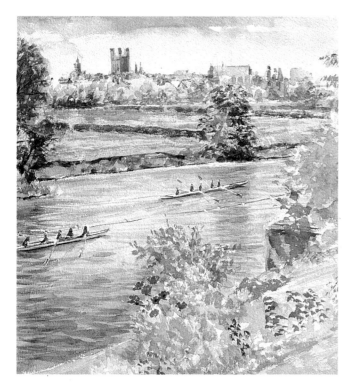

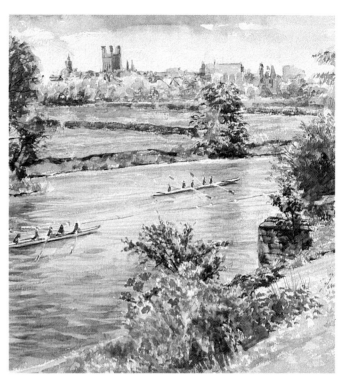

(Above right) I applied further cool washes to the trees and wall to the right of the foreground and then some linework to suggest branches in the trees and stonework on the wall. Occasionally, I introduced a touch of bright scumbled colour to give some bite. The direction of the brushmarks in the leaf textures at the base of the wall indicated plant growth. A warm, dark accent was laid at their base to act as a foil against all the light greens. The

vegetation was then overlaid with warm textures which lead the eye to the central foreground.

Here bright accents of colour were used to bring the vegetation forward, before applying the cooler shadow areas and line detail on the stalks and stems.

This shadow area is important as it breaks up the foreground with a diagonal sweep. It moves from a cool green in deep shadow to a yellow green in areas of sunlight.

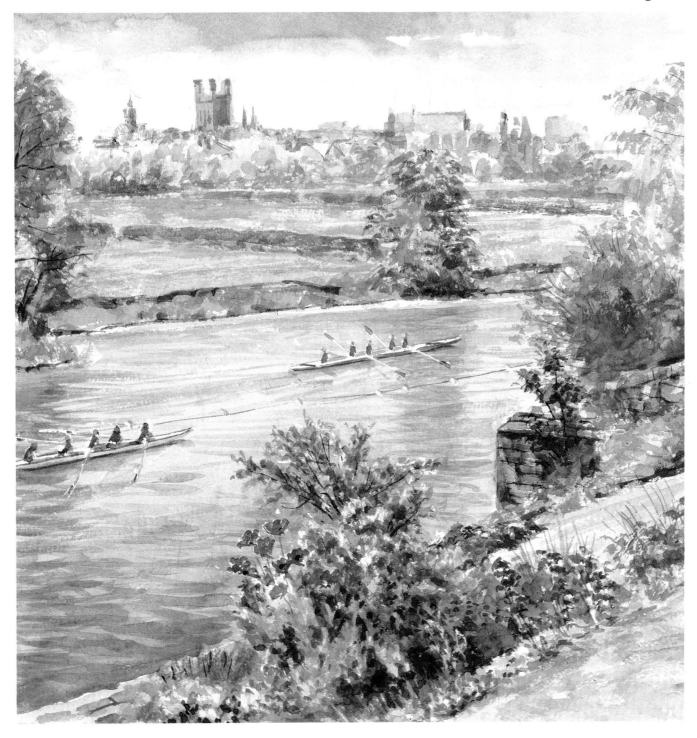

These same shadow areas of undergrowth were then given some warm accents of colour at their base, giving a glow to the greens. Applied using the pooling technique (*see page 74*), the paint dried to create a hard, clean edge. These patterned accents were varied according to the species of flower, making this negative painting as important as the positive pattern of the leaf shape.

It is important to note the areas I decided to omit in the foreground, for example, the small tree in front of the wall on the right. Losing such areas as this allows the silhouettes of the shapes which are retained to work against each other more dynamically. Remember, you are not a camera forced to record everything. You can be selective, choosing from nature those aspects which best reflect the needs of your painting.

The contrast at the water's edge *(bottom left)* is accentuated by a line of ultramarine blended into the water.

Wet on Dry: Common Problems

PROBLEM When painting behind objects do make sure that you go right up to their edges. If you don't, the objects, in this case the trees, will have a white outline around them and the colours will float in between, appearing unrelated to the subject.

PROBLEM The scumbling here looks dirty and excessive pressure was needed to achieve the texture.

SOLUTION Starting at the edge of the tree, pull the brush away from it. This will ensure no white gaps are left, giving the tree definition and solidity. Make sure the brushmark is carried through to the edge of the object alongside.

SOLUTION Add a little water so the scumbles become more fluid and easier to apply. For lighter scumbles the paint may be very fluid. Remove any excess liquid before application, having first tested on a spare sheet of paper whether you have left enough liquid to apply the scumble.

 Too much water and the scumbles fill in *(right)*. Reduce the amount of water or add aquapasto to thicken the mix.

PROBLEM If you lay washes of mixed colour on top of each other all light falling on the surface will be absorbed and the colours will become grey or dull.

SOLUTION Keep your palette mixes as simple as possible, achieving more complex mixes by layering colour on the actual paper surface and not mixing on the palette.

PROBLEM If too much work is carried out on one area during layering of colour, it will result in the underlayers redissolving and mixing to produce grey or dirty colours.

PROBLEM When applying brushmarks and textures it is natural to fall into a rhythm, creating regular patterns *(below)*. This mosaic-like paint structure, unless part of your particular style, can become intrusive and unnatural.

SOLUTION Produce layered colour with speed and fluidity. Do not linger or rework an already wet area. Your colours will then lie in separate layers and remain clean.

SOLUTION Be alert to regular patterns emerging. If this begins to happen, change the rhythm of your brushmarks, vary their size and direction and make sure the negative spaces between them vary *(below)*. This will give a more irregular and, thereby, a more natural balance to the study.

PROBLEM The brush head here is refusing to point and is therefore difficult to control while attempting to lay even washes or paint details.

SOLUTION It may be that you need a new, bigger or better brush or that there is not enough fluid in it. If the internal hairs of the brush head are dry there is nothing to hold them together and they tend to splay, a problem rectified by applying more paint to the brush. A generously loaded brush will also cover a large area before a refill is necessary. Small brushes tend not to hold much paint and if they are not refilled regularly will splay open.

Wet on Wet

I have always felt that wet on wet is the ultimate technique in watercolour practice. Its fluidity and softness suggest movement and depth.

Laying the pigment on to a wet surface allows for a stronger concentration of pigment in the dark areas. Building up paint to express such areas often creates overworked and dirty colours in other techniques — whereas here, the dark wet areas dry to a clean, rich finish.

The paint edges are soft as the pigment floats on to a wet surface. When edges are soft our eyes suggest that they are out of focus. Consider the way you observe the world in comparison to a photograph. Within your eye there is only a tiny window of focus through which you see. For example, as you speak to someone, notice how you have to move your focus from one of their eyes to the other, in order to see both. The rest of their face is out of focus. Outdoors, when viewing a scene, at first we feel we are seeing everything — but concentrate your mind and you will realise that the small window of focus skips around the scene, while your eye is aware of the rest of the landscape only as a soft blur. This is how we see.

In a photograph, large areas are in focus, often producing a stiff, unreal, frozen quality. Another problem is that a wonderful view may be unobtainable to the photographer due to the presence of some over-dominant feature. The painter has a considerable advantage, in that he or she can create an image in which large areas are out of focus. The technique best employed for this is wet on wet.

For the beginner

The sensation of freedom when applying the paint using this technique is tremendously exciting. At first the beginner will feel slightly out of control. But stay with it, although it does take practice. Once you have mastered the flowing paint the rewards are worthwhile. I always explain that the best watercolours are 'controlled accidents'.

As you gain confidence you will learn to allow the paint to suggest detail which at one time you would have spent hours trying to create. This allows the natural

qualities of the paint to shine through in all their beauty. At the same time, your audience gains the pleasure of using their imagination to interpret your work.

In the field

It is wrong to assume that because you are working on a wet surface with fluid paint that you necessarily have to work fast. Again, practice is essential to achieve the

correct balance between the wetness of the surface and the volume of liquid in the brush.

All of the pieces featured in this chapter were painted on an upright board fixed to an easel. I would recommend that you start this practice from day one as it simplifies working outdoors and avoids unnecessary distortion in your proportions.

The practice of wet on wet

In my mind there is no doubt that mastering this technique is one of the most difficult artistic disciplines. The finished paintings always look so simple, containing all the essential qualities that exploit the full potential of the medium. Simplicity, while effective, is often difficult to achieve. I can assure you that, with practice, you will soon loosen up and begin to see exciting results.

More than any of the other watercolour techniques, wet on wet depends on achieving a feel for the materials. Each time you pick up a brush the circumstances will be different. On a hot or windy day your colours

will dry faster. A little too much water and your colours will spread. You must constantly adapt to these changes. At first you will find this frustrating. But remember what it was like learning to ride a bike. You could steer, pedal and balance – but not all at the same time. Then suddenly, they all came together. You had the feel for the technique. Such is the feeling when you first master true watercolour.

Some day, when you are truly attuned to the medium, you will paint a picture and it will almost seem to paint itself. Every artist, at some point in their life, experiences this. Supposedly, this is where the idea of a muse came from. I can assure you that these rewarding moments will be worth all the energy that you will have expended to achieve that level of competence.

Tube colours are essential for this technique to enable you to achieve a thick mix of paint which will not explode across the wet surface. Buy Artists' watercolours, which redissolve more easily when they dry on your palette than do the cheaper ranges. (Remember, buy Artists' watercolours *not* watercolours for artists – the latter is often student quality.) *(From left to right)* cadmium red, crimson red, ultramarine, Prussian blue, lemon yellow, cadmium yellow.

The palette illustrated here will enable you to squeeze your colour into the wells whilst actually mixing it on the flatter central portion. Colours should be mixed thick and are not difficult to control even if the palette is held at an angle.

You must have a roll of absorbent tissue. Many techniques depend on being able to remove a controlled amount of paint from the surface, or preventing paint reaching certain areas.

Two jam jars with their lids provide you with a portable water supply. Keep one for cleaning your brush and the other keep as clean as possible for mixing with your paint.

A soft putty rubber which you can knead into shape and is unlikely to damage the paper.

A 0.5 mm automatic pencil (2B) – this fine-line pencil produces marks easily hidden under soft watercolour washes.

A No. 12 round brush – an expensive brush in pure sable, but don't reduce size, go for a slightly cheaper mix such as ox and sable or nylon and sable. Avoid very soft hairs, e.g., squirrel.

A 4.5 cm (1¾ in) hake – it is almost impossible to work wet on wet without this brush. It comes into its own when rewetting previously laid washes of dry colour. It is so soft it floats over them, laying water without damaging paint. You can also paint with this brush.

A 1 cm (⅜) nylon flat wash brush – you can paint with this, but I like to use the chisel edge to lift colour. The spring in the nylon creates all the surface friction you need.

Art masking fluid to create the sharp highlights, unobtainable with lift off.

Thick watercolour paper (300 gsm [140 lbs] or over) as the heavy wetting required will buckle thinner papers to an intolerable degree.

Drawing board and easel – the former is essential for supporting your soaked paper and the latter for holding it at the correct angle for easy paint application.

Gumstrip, 5 cm (2 in) wide, for stretching paper in case of heavier wetting.

Wet on Wet: Materials and Preparation

All paper cockles when wet and for this technique to be successful you will need to soak it (*see page 13*). You will find that the thin papers will soon resemble the waves on the sea while the thicker ones will buckle and refuse to lie flat. It therefore seems sensible, in my opinion, to stretch all but the very thickest of papers before employing a wet-on-wet technique.

The essential brush for this technique is the hake. This is made from very soft goat's hair and therein lies its value. When building up layers of colour you do not want them to mix as a muddy colour will result. This poses a real problem when practising this technique as, when applying subsequent layers, you need to wet those already laid. Most paint brushes have a degree of bounce in their hairs which causes friction on the surface, resulting in paint lift if used for rewetting. The hake, on the other hand, is so soft that it causes little surface friction and holds a large quantity of fluid which is rapidly and softly dispersed over the surface. It is even possible to rewet semi-dry paint, although you will obviously risk causing backruns if the hake is holding too much water.

To remove excess water from the hake you can flick it. If you do this hard, the brush will become thirsty – that is it will eagerly soak up water or paint. If you are indoors where flicking may cause a mess, you can squeeze the hake in a tissue. However, do not squeeze and pull the hairs as this may well tear the hairs from the brush. Another method is to slap the brush head flat on to a tissue – this also shapes the brush. When I am wearing old jeans and painting outdoors, I often do this on my thigh, much to the amusement of onlookers.

In my opinion it is far better to buy the traditional hake with the hairs bound into a balsa-wood handle. I have found that those with metal ferrules tend to rust easily. The price of hakes do vary, but my advice, as always, is to go for the best. You will find that the head of a good-quality brush actually improves with use, gaining a sharp edge. Never lend your hake to anyone; the brush which will have matured in your hands can be destroyed so easily if it is not cared for.

Some artists even paint with the hake either by using a corner of it to apply the paint, or by shaping the soft hairs with their fingers, before or after loading it with paint, and applying this shape as a mark on the paper. There are small and large hakes depending on the area you wish to cover. Experiment with them all when you have time. They may well change your whole view of watercolour.

The 'lift off' technique, described fully in this section, is to wet on wet what resists are to wet on dry and will produce, on the right paper, beautifully soft highlights. You therefore need a brush which will create surface friction. A flat nylon brush is excellent for this purpose. It has more bounce than a sable one and is much harder wearing – an important consideration as you will be using it to rub against the paper. I have found the sharp, chisel edge of a flat wash brush to be superior to the point of a round brush for this technique. The hairs supporting one another make the brush less yielding, resulting in a more effective lift off.

The paint mix needed for this technique is generally thicker than previously required and is more easily combined on a flat surface. When it comes to choosing a palette for this technique, therefore, I would go for one with a flat centre, wells around the perimeter and a thumb-hold to give a firm grip. The flat centre is for mixing, while the wells hold the squeezed-out pigment which can be left to dry for re-use.

Finally, it is helpful to have a well-sized paper on which to work. Paper has both internal size which holds the fibres together and external size providing a hard, protective coating. Good papers have a good 'rattle' when you shake them. This rattle is produced by the stiffness of the size.

The best papers are those that are tub-sized. This means that once the paper has been made, it is dipped into a bath of glue size and then hung up to dry.

You can buy your own size, ready-mixed, in bottles or in granular form. The latter is usually sold as an oil-painter's size, but you can make up small quantities which need to be painted over your stretched paper, the day before you need it. This will improve the strength, the lift-off quality and the colour retention properties of the paper. If you make up some glue size from granules don't try to store it in solution; it goes off very quickly as it is made from animal extracts.

Although adding your own size is helpful if you are having problems with one particular batch of paper, it is better in the long run to experiment with many types of paper until you find a paper with a size that suits your particular style of painting.

Papers with little or no size act like blotting paper. The pigment stains the paper fibres immediately. Sizing acts as a barrier. When wet it is like a jelly and stays on the paper surface; when dry it forms a hard shell. When you paint on this, the majority of the pigment is trapped in the size. A little stains the fibres depending on the tinting strength (staining power) of the paint. Excess pigment that cannot be absorbed by the size lies on the surface and it is this which is most easily removed. If this surface is rewet, the size turns to jelly but does not release the pigment until you apply friction and remove the size itself. Thus the size initially prevents pigment staining the paper but then holds on to the colour until it is itself disturbed. Without these qualities the lift-off technique would be difficult, if not impossible, to exercise.

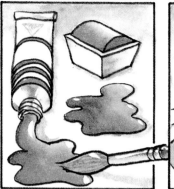

Tube colours are essential as they can be used with little water. The density of pigment required is impossible to achieve with pans.

Dipping into a pool of tube colour with a dirty brush leaves little or no residue, while pans dirty easily.

Heavily sized papers often resist water or colour initially. Add a touch of Ox Gall (water softener) to your mixing water. Mark jar so as not to confuse with cleaning water.

If you use heavy paper and decide not to stretch it, large cockles can be removed after painting. Firstly mist the back using a plant spray. . .

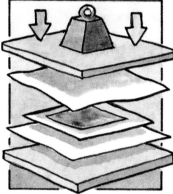

. . . and then sandwich it between two thick sheets of blotting paper and two pieces of plywood. Place weights on top to assist flattening. Leave for 24 hours.

This enlarged cross-section of paper with little surface size shows how it will act like blotting paper. Surface dries quickly and pigment stains the paper fibres.

Well-sized paper, however, stays wet longer with bulk of pigment held in the size. Only a small amount of strongly staining colours ever reaches the paper fibres.

Heavily laid colour will leave pigment on the surface but this can lift on rewetting. Size turns to jelly but sticks to paper.

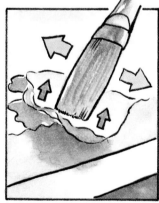

The colour in the size is protected until friction is applied with a brush and then both can be removed.

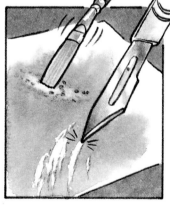

However, colour which has actually stained the paper fibres is impossible to remove without removing fibres. Whatever way this is done paper damage will occur.

When dry, the size is hard and protects the surface from abrasion, e.g., use of putty rubber.

Note: overworking wet paper on which size has softened and been removed can lead to damage. Such areas, with exposed fibres, absorb colour like blotting paper.

Wet on Wet: Artstrip

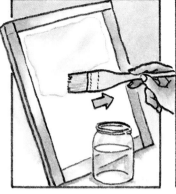

Wet-on-wet brushmarks – wet paper heavily and evenly using hake.

If paper won't cover evenly, try adding more water to brush. If this doesn't help then add Ox Gall to the water. This breaks water tension and helps water spread.

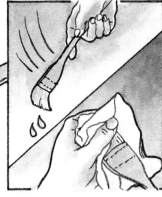

If surface becomes too wet, flick hake strongly or squeeze in a tissue (don't pull the hairs).

This thirsty hake will lift excess water but avoid undue pressure or it may work so well that it completely dries surface.

If you work upright, excess water will run off naturally.

Wet a round painting brush and give a soft flick. This will shape it while retaining enough water to apply paint mix.

Using only this trace of water, pull a thin layer of colour repeatedly across the palette surface.

This will mix the paint evenly in the brush head and avoid clogging with lumps of thick paint which prevent an even application of colour to paper.

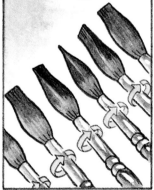

The brush will be shaped by the dry paint and become slightly flattened as shown above (brush shown from all angles).

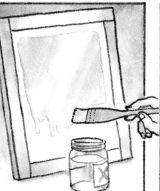

Rewet the paper. The first layer will have been absorbed, thoroughly wetting the paper fibres. This second layer dampens the surface again.

If you work flat, water collects in the valleys of the paper as it expands, even if the paper is stretched.

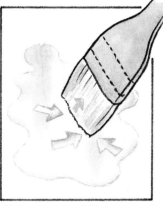

This water should be removed with a thirsty hake before applying colour.

Look across the paper against light to ensure an even dampness across whole surface.

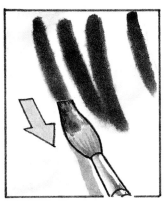

Place flattened edge of loaded paint brush against paper surface, at a very small angle. Apply paint by pulling brush across surface to retain its shape.

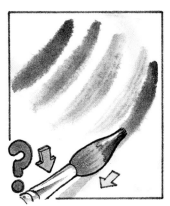

Note differing tonal strengths of marks produced by changing pressure of brush head on surface.

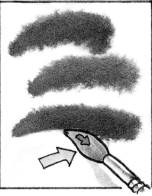

If colour spreads slightly, lift off with a thirsty round brush.

By applying dry colour first to one side of brush head and then other, form it into a chisel shape . . .

. . . the edge of which is essential for creating fine, soft lines on a wet surface.

Using thinner colour – add more water to mix and brush will regain its point. If you want a chisel edge you must now use a flat wash brush.

Mix colour well using whole of brush head and test on spare paper. Avoid deep pools of colour. Judge darkest tone available with mix by transferring to a wet surface.

On a new sheet of paper, repeat wetting process as previously described. Remember to wet paper before and after mixing paint.

With a heavily loaded brush drop a blob of colour on to wet surface and same amount on to a dry one.

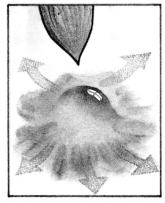

On the wet surface the colour has no dry edge to contain it. It explodes on the surface as it finds its own level.

Reduce amount of liquid in brush head by wiping on tissue or edge of palette.

Wet on Wet: Artstrip

Now when colour is dropped on to the wet surface both it and the brush head contain similar amounts of fluid so no explosion of colour should occur.

And the brush mark stays in place.

By applying different pressures on the brush, you can change strength of colour tone, but can go no darker than your first test indicated (*see page 93*)

Let first colour dry. Test for dampness with back of fingers. If it feels cool or 'grips' your fingers, it is still wet internally and colour will lift off if you rewet it.

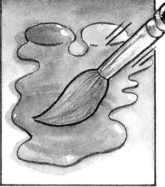

Mix second colour before wetting surface as only one wetting is possible once surface pigment is present. A second wetting would lift off paint.

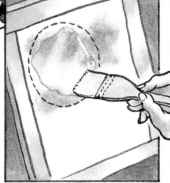

Wet a small area which you feel you can cope with before drying occurs.

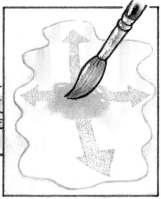

Caution – wetting too small an area can result in hard edges occurring where a fine film of pigment spreads unseen across the wet surface.

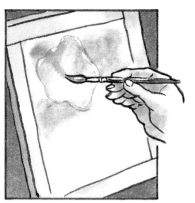

Your second layer can now be applied. Don't overwork or you may lift the previous layer, mixing the two.

An exciting variation of brushmark can be achieved by applying one colour to one side of your damp brush . . .

. . . and a different one to the other.

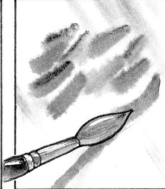

This creates a variable paint colour in the brushmark.

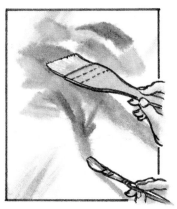

Try same technique using a hake and/or nylon wash brush.

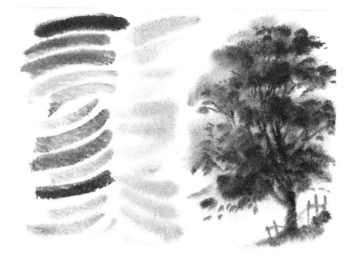

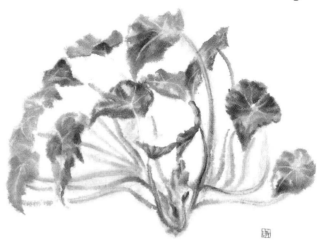

Practise your brushmarks until you get the feel of wet on wet. Start with a thick mix of paint, moving on to a more fluid consistency as shown above (*left*). Once you gain confidence try your hand at the tree. This example was painted solely with a No. 8 round brush and the paper wet only once. The paint was of a stiff consistency throughout and the lighter areas achieved by applying only light pressure on the brush head. To create the branches a thin stroke was required, so I shaped the large round-headed brush into a sharp chisel edge by using the stiff paint (*see page 93*).

This plant study shows the possibilities when more than one colour is loaded on the same brush head. Here, a combination of red and green was applied by rotating the brush as it travelled over the surface of the paper, creating this unique colour change which was perfect for the stems of the plant. This colour combination was employed again on top of the leaves, having first worked the outline of the leaf silhouettes in a light yellow green. Both here, and on the stems, the light veins were achieved by lifting off the colour with a thirsty round brush before it dried. The red undersides of the leaves were completed using two reds on the brush head worked on to a ground work of the same light yellow green that was used for the silhouettes. Only a small section of the plant was selected from its complex of intertwining stems. The leaf shapes and stems chosen for the study complemented each other in shape and rhythm, and those upsetting the balance were omitted.

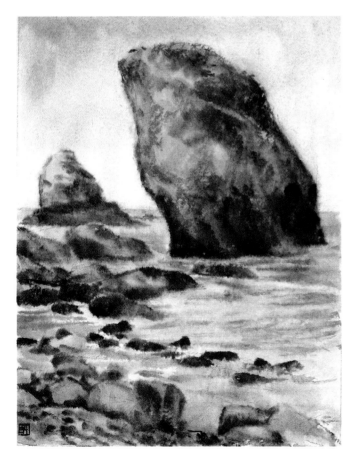

This sketch was completed using three layers of wet on wet. It is an exercise in brushmark strength. If a dark enough tone is not achieved for the rocks, the water will not be light enough by comparison and the foreground will be dead. The lighter brushmarks on the sea were applied with a thinner colour so the amount of liquid on the brush had to be carefully controlled to prevent it from exploding and covering all the light foam areas. Note also the warm colours on the large rocks – and how subsequent, overlaid cool brushmarks bring them to life by adding colour and tonal contrast.

Wet on Wet: Working From A Photograph

Another joiner photograph was needed here to encompass everything I wanted to capture in this scene. The main subject, the temple and the yellow flowers, were nicely framed between the foliage of the bamboo on the left and the two trees on the right. The backdrop of cool greens behind the building was a wonderful foil for the warmth of the wood from which it was built. Finally, the reflection of the flowers in the water added to the tranquillity of the scene. I had painted this scene many times before, but catching the flowers in full bloom was an added bonus which, at the time, I was only able to take advantage of through the use of my camera.

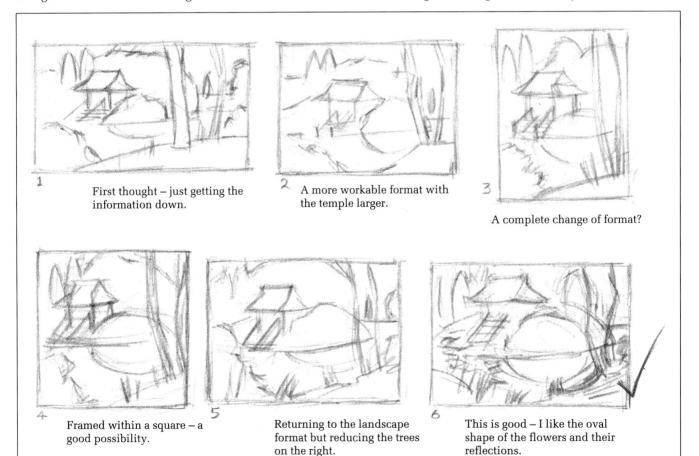

1 First thought – just getting the information down.

2 A more workable format with the temple larger.

3 A complete change of format?

4 Framed within a square – a good possibility.

5 Returning to the landscape format but reducing the trees on the right.

6 This is good – I like the oval shape of the flowers and their reflections.

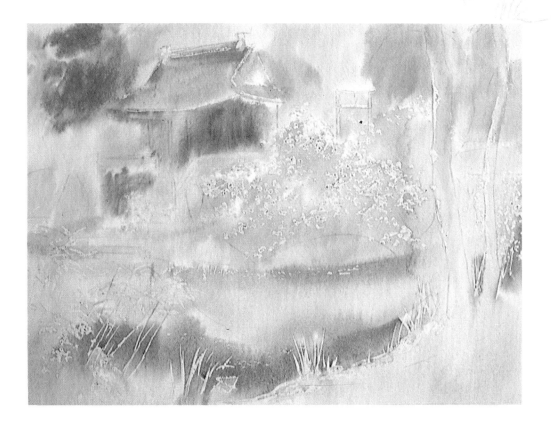

(Above) Here I am transferring the proportions from my thumbnail to the watercolour paper. As you can see, I keep a special little sketchbook for my thumbnails which I produced at the same time as taking the photograph. In this way I ensure the integrity of my original view of the subject. They could be drawn on any scrap piece of paper but be sure not to lose them.

(Above right) The drawing grid was first laid out ensuring the high placement of the temple: the dominant elipse of the flowers and its echoing forms on the bank were all accurately transferred from the thumbnails.

(Above) The rhythmic structure of the drawing is further enhanced. However, pencil was kept to a minimum as over heavy linework easily shows through wet-on-wet watercolour. The lines that I used were reduced in strength by dabbing them with a putty rubber before the painting began.

(Left) It would have been impossible to paint around certain areas such as the yellow flowers and the foreground undergrowth. These areas were therefore masked and can be seen as they partially resisted the first wet-on-wet washes laid over the entire painting. Notice how the rhythms and structures are carried through in the application of the masking fluid.

(Continued on page 104) 97

Wet on Wet: Working In The Field

This was an extremely difficult painting to visualise. At first sight I had no idea how I was going to marry this huge, bright red column in the foreground with the fine detail on the distant building. The column also broke the composition into dark shadow on the left and bright sunlight on the right. Yet this was the best view. In a situation like this I always fall back on my thumbnails and simply begin to make marks. It is only when you see something on the surface of a piece of paper that you can begin to make decisions about composition. Once I had actually started this picture, I became extremely excited by the challenge it offered. You will find that if you have a system for starting off, it'll help enormously in difficult situations such as this and you may find yourself carried along to such an extent that the picture can sometimes seem to compose itself.

1

These are the elements I wanted to capture, but there was too much space for the walkway.

2

I introduced the railing but it leads the eye out of the picture.

3

This takes in the full height of the column, but includes too much water and pathway.

4

Focusing in on the column and the boat. . .

5

. . . but now with a little more breathing space.

6

I liked this, but I'd given myself a wide view and only a day to do it in. Wet on wet was the perfect choice of technique.

(Above) Here I am, beside the imposing painted columns on the quayside. Whilst the position looks rather vulnerable, I was actually quite comfortable. Tucked away, with the column behind me I did not pose an obstacle to passers-by, even when one or two stopped to watch me at work.

(Above right) Masking fluid was applied to the masts and roof of the boat, the bridge behind the boat and highlight areas of the distant building. Having already wet the surface once and mixed the colour, I rewetted the surface and applied the highlight colours. I ensured that the paint edges would be soft throughout by working from the back.

(Right) The right edge of the large pillar was tidied up using lift off and the masking fluid removed from the building. The distant building was rewet and painted with warm and cool areas to suggest sunlight and, while still wet, dark warm accents were applied to indicate soft detail. Its bright green dome was applied just before area dried out.

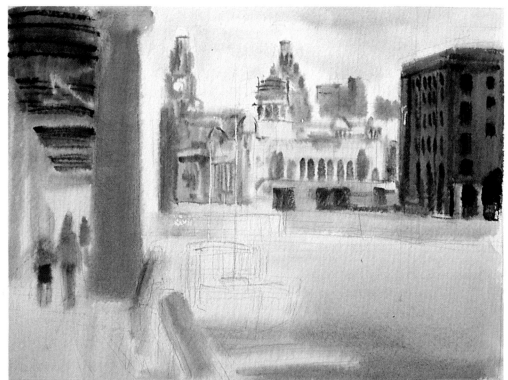

(Left) I then began work on the walkway and the warm building on the right. Moving across the painting like this prevents backrunning into recently applied paint. After rewetting, structural areas of colour were applied and before they dried accents on the struts and windows were added with stiffer paint.

(Continued on page 106)

Wet on Wet: Artstrip

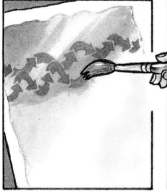

Flat wash – mix colour to required strength and apply to top of wetted area. Work down in bands, keeping brush head in contact with surface.

Before colour runs out, recharge brush and continue to bottom of area. Unevenness of colour which can occur as brush leaves surface is lifted with a thirsty brush.

Graded wash – apply colour in bands as before, but don't recharge brush. As the paint runs out the tone lightens.

Halfway down the brush may begin to run out of fluid colour with coverage becoming patchy . . .

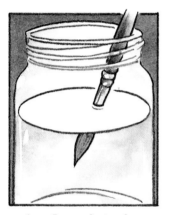

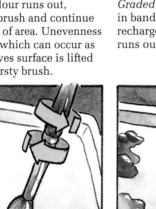

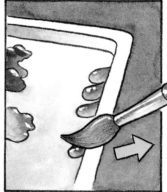

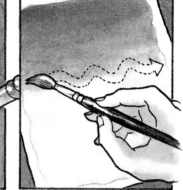

. . . for a flat wash simply apply more colour to the brush. For a graded wash dip the brush head in water taking care not to shake or stir it.

Carry this brush to the clean palette and swirl the brush head on its surface, mixing the water you have just picked up with the colour in the brush head.

Remove any excess fluid on the edge of the palette to avoid backrunning.

Apply this mix to the bottom half inch of unfinished wash and continue as before almost to the bottom of the wet area. Repeating this process . . .

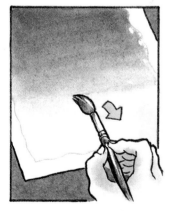

. . . colour will almost have disappeared by the time you reach the bottom. Gently squeeze clean brush between fingers and then 'feather' away bottom edge.

Drawing – pencil marks tend to show through soft-edged colour. Once painted over, the gum in the colour will fix it to the surface. Keep it as light as possible.

Think of drawing more as scribbling. This will make you more relaxed with a lighter touch. The drawing must be faint . . .

. . . so you can erase the unwanted lines, especially those in lightly coloured areas, with a putty rubber, before you begin painting.

Instead of wetting paper with a hake, you can use still-wet stretched paper. Damp paper won't accept pencil and surface will be damaged so stretch paper after drawing stage.

The paper will be wet both top and bottom (as this cross-section shows) and will stay wet for some time.

When working at an angle, start applying the paint at the top as this will dry first.

It is also natural to work forwards from distant areas, using a thin wet mix, overlapping masses closer to the foreground.

Here the tree masses are completed in thick (dry) colour which renders them more solidly.

These coloured highlight areas cover the majority of the white paper and silhouette the main masses of the composition.

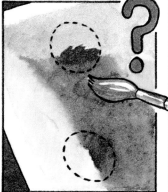

Make sure all edges are soft. As soon as a hard edge appears stop working in that area.

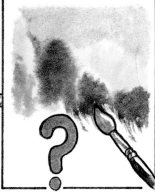

Halfway down the surface may begin to dry out. You can wait until work has dried completely and then rewet, or rewet the partially dried surface by . . .

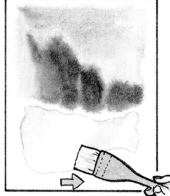

. . . rewetting the main body of white paper with a well-loaded hake, avoiding paint edges by about 6 mm (¼ in) or backrunning will occur.

Refill hake but flick off excess water (this takes practice – if you flick too strongly you will make hake too dry or even thirsty).

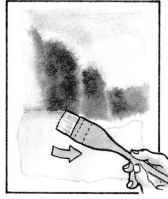

The final 6 mm (¼ in) can now be rewetted without backruns.

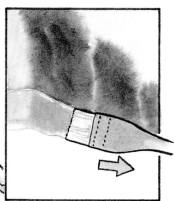

With the correct water balance you can even travel across slightly damp colour without it running. The hake is the only brush soft enough to do this.

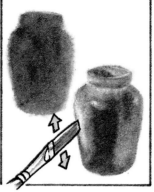

Lift off – this technique can be used on any layer, once it has dried, to give soft highlights with a textural quality. Latter is dependent on paper's texture.

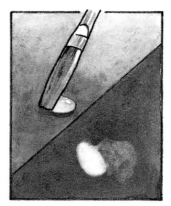

Brush should be slightly damp. If too wet it will leave a blob of water on paint surface causing uneven lifting.

Rub tip of damp brush across surface. This softens and dissolves size and dislodges pigment. A flat nylon brush is more aggressive than a round sable one.

Dab pigment off immediately with an absorbent tissue.

Unwanted hard edges can also be removed in this way.

Work on a small area at a time, dabbing frequently to control result.

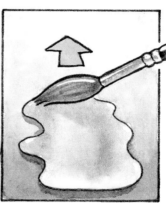

Partial lift off – this can be achieved over a larger area by wetting surface once with side of large brush. No rubbing or undue pressure need be used.

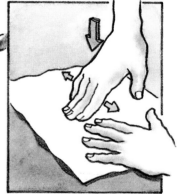

Lie a clean piece of absorbent tissue over the area and press hard. Keep tissue still with other hand.

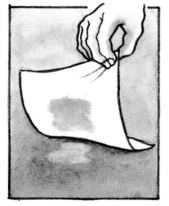

A thin layer of the colour will be absorbed by tissue.

Allow to dry and repeat process as many times as required.

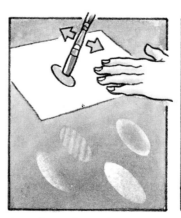

Stencils can be cut from paper, or low tack masking film, for lifting off a more controlled, sharper-edged area.

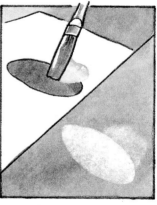

Ensure brush is not too wet to prevent leakage under the edge of mask, causing unwanted lift.

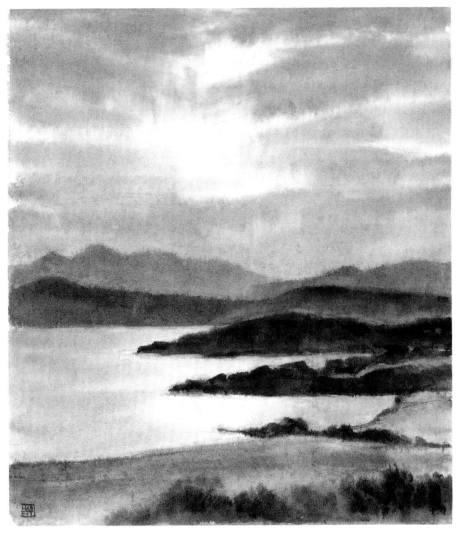

The sky in this study was first painted as a graded wash moving from blue at the top through to yellow green to pink at the horizon. The clouds were then blocked in, as silhouettes, in a dull orange and overlaid with a dense dull green. Although there is the temptation to work into a sky like this, you must develop the discipline of laying the colours and then leaving them. As they dry they will spread and mix with one another, producing exciting results. If you fiddle with the colours while wet they'll become dirty and overworked.

(Below) This study represents the limits to what can be achieved using watercolour with regard to density of pigmentation. The only way to achieve this depth of colour, without it becoming dirty and overworked, is to apply it using a wet-on-wet technique. I applied several layers of colour, building up the form as a series of dark silhouettes. The lighter tones were then achieved by the use of lift off. The surface is so heavily covered with paint it is very fragile as some pigment lies exposed on top of the size. When using lift off therefore it has to be carried out with great care so as not to expose too much too quickly. Colour was then applied to the dry lifted areas.

(Right) Having sketched the most minimal of outlines, I applied colour almost directly from the tube. This thick creamy paint covered the paper solidly and at this stage gave definition. Areas of light were painted with unmixed colour, for example, bright red ears, whereas areas of shadow were covered using complementary mixes with a tendency towards blue. When dry the fur effect was achieved using lift off. This was executed freehand while for fine details, such as the whiskers, I used a fine paper mask.

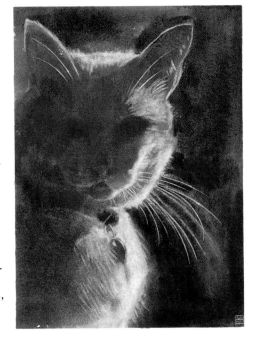

103

Wet on Wet: Working From A Photograph

The page below shows the basic principles involved in painting water. Our eyes usually focus on the water's surface and we are aware of, but generally ignore, the reflection in the surface unless it is unusually sharp, as in still water. As the water surface becomes disturbed, the reflection is elongated (1). I first wet this arch and then applied a graded blue wash which became lighter towards the bank. While this was still wet I used the flat wash brush to produce downward strokes of thick paint. If pressure is released at the end of each paint stroke the brushmark becomes lighter toward the bottom (2).

On the right-hand side of the page I have shown various methods for suggesting surface detail:

3. Scratching with a scalpel.
4. Lift off using a flat nylon wash brush.
5. Dropping a thin line of water into the washes before they were dry, to give a gentle, fine and light, horizontal backrun.
6. Using masking fluid to suggest detritus. Protected areas can be coloured in later if desired.
7. Rewetting and applying horizontal strokes of a darker colour.
8. Dropping dark lines of colour into a still wet wash.

'Sketchbook' Techniques

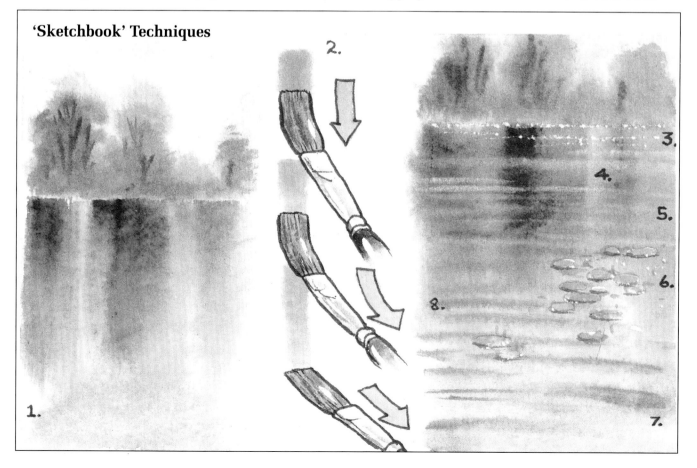

(Above) Halfway through the painting and I'm really into my stride. Working in layers, as I do, you can see the picture developing over the whole surface not unlike the progression of a polaroid photograph.

(Above right) I removed the masking fluid and then applied a fresh layer. This may seem tedious but it is well worth the effort. If the same masking fluid had been left on for the duration of the painting, the resist would appear too strong and obvious. A second application does not, nor can it, cover exactly the same areas as the first – especially with scumbling. The resulting resist was therefore more irregular, giving it a natural quality. It also protected areas of colour as well as the white paper, for example, the wooden trellis by the temple.

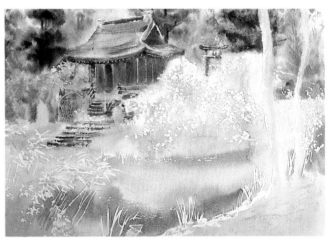

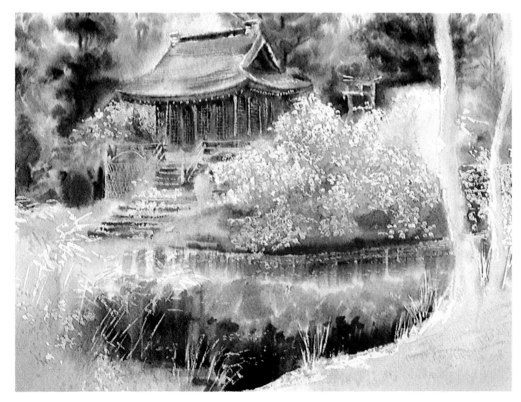

(Above) As usual, I started work at the back of the composition and worked forward. The painting was rewet and painted in sections. Notice how the sharp masked qualities of the temple stand out against the soft backdrop of the trees. Note also how I have overlaid the warm timbers of the temple with complementary cool washes.

(Left) The temple bank, its flower bushes and the water were then strengthened. The bank and foliage received colours of the same family with contrast achieved through tonal change. I applied much cooler complementary mixes to the water, giving it more depth and contrast, especially where it meets the foreground bank.

(Continued on page 112) 105

Wet on Wet: Working In The Field

It is important that figures in a painting should appear in scale. Look at the door in diagram A. The top and bottom converge to vanishing point 1. Figure 4 is then drawn in the doorway, relating the figures to the building. Extend the parallel, horizontal lines from figure 4 to figure 5. Figures the same distance from us are of a similar size. To ensure the correct height of a figure in relation to figure 5, decide where you wish your figure to stand and mark the point on the ground (6). From this point take a line through the feet of figure 5 and extend it to the horizon (eye level). From this measuring point (2) take a line through the head of figure 5 and extend it until it is above point 6. Extend a line upwards from this point and you'll find the figure's height is where the lines cross. Construct figure 7 in a similar way. Diagrams B and C show different eye levels – try them all. Diagram D shows the position of the figures in the painting opposite.

'Sketchbook' Techniques

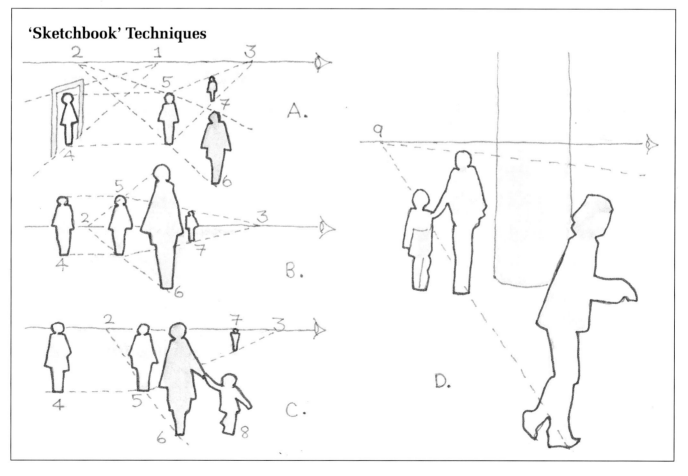

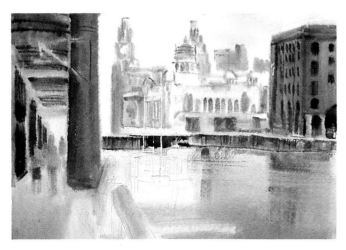

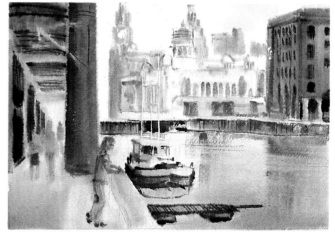

I laid stronger, graded washes over the water and the floor of the walkway. While the water area was still wet, the warm reflections of the buildings were pulled down and then partially lifted with a tissue to suggest surface disturbance. The pillar, windows and dock wall were rewet and overlaid with rich washes. Dark details and linework were applied before drying.

The remainder of the masking fluid was removed and the boat, pontoon and foreground figure blocked in and detail added. Everything was achieved with a No. 8 round brush, using the side for flat colour areas and the dry chiselled edge for detail and linework.

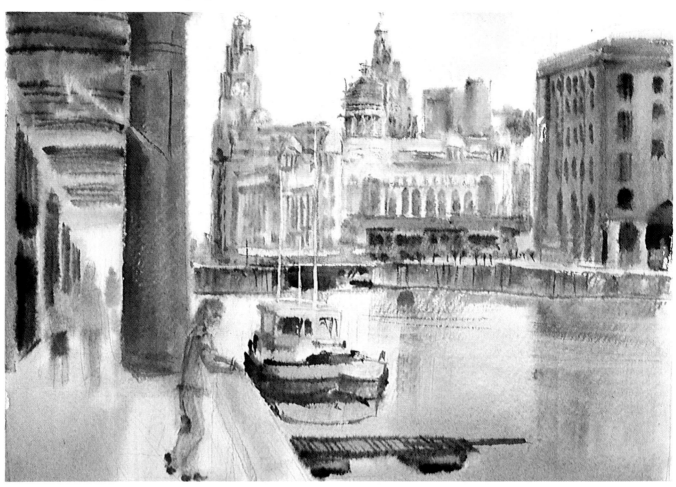

Masking fluid was laid over the coloured highlights of the boat and distant building. Masking was kept to the central portion of the painting to keep the eye focused within this section. Once dry, the distant building was rewet in small sections and cool details added.

(Continued on page 114) 107

Wet on Wet: Artstrip

First layer fills in masses with highlight colours, in order to register the silhouettes of the composition.

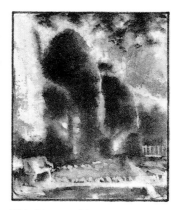

Second layer adds darker tones to give volume and depth.

Third layer adds texture. In this way the painting 'develops' much as a polaroid photograph would, across the whole painting surface rather than in isolated areas.

Resists, such as masking fluid, can be employed at any time during this layering.

Masking fluid resists can be applied on the raw paper surface or on top of colour.

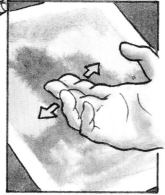

But ensure the surface is completely dry before applying.

These resists can be used to create hard edges, if they are required. Colour can be added, once masking fluid has been removed.

Wax resists are softer and work well with soft-edged work.

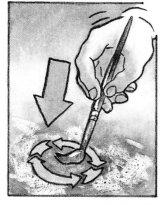

If you overwax, don't despair, try exerting more pressure on the brush to push colour into wax and increase coverage.

Lift off at the edges of resists (fluid or wax) can soften or loosen them depending on your requirements.

Scumbles into a wet surface can be achieved by using very stiff colour.

For lighter scumbles, add aquapasto to mix to stiffen.

After completion of first layer you have no choice but to leave it to dry thoroughly. If you continue too soon, uneven lift off will occur and you will lose control.

Speed things up at home by using a hair dryer. You will learn from watching the colour changes that occur.

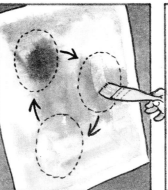

Now rework section by section, moving on as each dries.

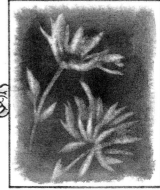

Lift off can also be used to suggest depth and volume.

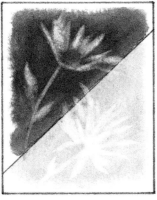

It is more effective out of a dark tone, so be bold when applying wet colour.

Colour can then be dropped into these areas either when wet or dry.

Although lifting off is a slow process it is very controllable and can express much soft detail.

Textures
1. Sponging – different sized sponges and even different sides of the same sponge give different effects – experiment.

2. Wax Crayons – layers of crayon have been over- or underlaid with layers of watercolour.

3. Ink – this resists wet watercolour washes when dropped into them. Here green ink resists red wash.

4. Artist's distilled turps – wetting surface with this instead of water creates texture when colour is subsequently applied.

5. Fixative – Wash this over when colour is still wet for a subtly different quality.

Wet on Wet: Artstrip

6. Methylated spirit – soak a piece of rolled tissue in the meths and apply to a wet wash for this unusual effect.

7. Tissue/plastic film – crumple into a wet wash and only remove when colour has dried.

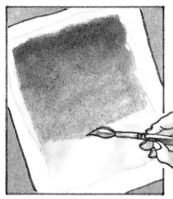

8. Salt – this is a favourite of mine. Apply a graded wash of wet-on-wet colour.

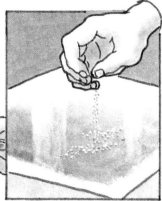

Lie board flat and sprinkle on some salt just before the paint dries and loses it's shine. Don't overdo this as you won't see the full effect for a couple of minutes.

Leave flat to dry. Salt crystals absorb water from wet colour, dissolve and release water again into the now drying colour. This produces miniature backruns.

Try again but allow to dry with board at an angle.

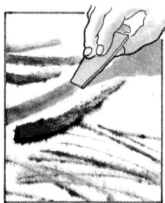

9. Cardboard – cut a piece to shape and apply tube colour direct to wet surface.

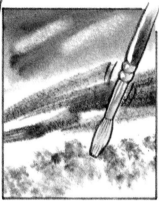

10. Oil-painter's bristle brush – use this to scumble, stipple and lift paint.

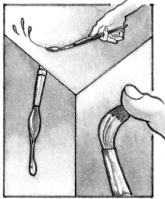

You can also spray, splatter or splash colour on to the wet surface.

Not all of these textures can be used together but they may sometimes help to get your imagination going.

Try watercolour pencils for creating detail and shading over soft washes . . .

. . . and then blend them in gently with a damp brush.

The white areas of this study were created with masking fluid which was applied before any paint. The snow effect was achieved with salt *(see opposite page)*. Each area – the sky, buildings, stalls, etc. – was painted separately so the salt could be sprinkled over them before drying occurred. Once all the sections were complete and dry, the masking fluid was removed. I then added yellow to the lights on the right and darkened the foreground snow a little to break up the white masked areas and give the snow more form. Do practise using salt on a simple wash before attempting a complex painting such as this as you need to know the exact degree of surface wetness required for the technique to work.

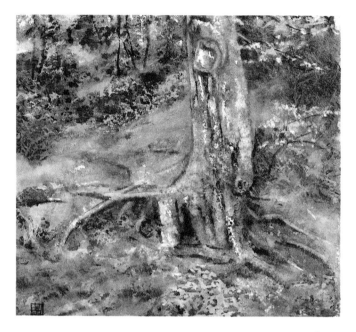

In this study of a tree root I have indulged myself in the creation of textures. Although I used the wet-on-wet technique, there are hard edges created by masking fluid and wax which were applied both on the raw paper and over colour. Salt was dropped into the washes of the tree trunk to create irregularities. Nearly all the texture which describes the fallen leaves in the background was produced in the following way. First a light orange wash was applied and allowed to dry. This was overlaid with a dark brown wash into which plastic kitchen film was crumpled, laid and held down with some weights until dry. Lift off softened some of these textures or joined them together. The picture was completed with dark linework laid in small controlled areas of wet on wet.

(Right) Here we have the full range of tones available in wet on wet from the soft bright light on the right through to the rich dark area behind the girl's head. This is watercolour at its most powerful. Masking fluid and lift off were used to create the details and textures in this study with a few final scratched highlights. These masked and scratched highlights form the focal points of the picture as they are hard edged, and great care must be adopted in deciding where they should fall. Most of the

detail of pattern on the kimono, for example, was achieved through lift off. This soft-edged technique does not draw the eye, unlike the scratched highlight in the cat's eye which does. Wet on wet therefore affords us not only the most complete range of tonal values, but also a complete range of focus from the soft blur of lift off to the sharp details of resists.

Wet on Wet: Working From A Photograph

(Left) I now worked on the trees to the right, the undergrowth to the left and the foreground. Here the direction of brush strokes became important in delineating the form and direction of these surfaces. I applied strokes down the tree trunks and diagonally across the foreground to lead the eye to the water's edge. To the left they were used to create the form and mass of the foliage which again curved towards the centre of the painting keeping the eye moving inwards. The small area of dense green foliage to the far right stops the eye travelling outwards.

Once the surface was dry, the second layer of masking fluid was removed.

Using all these tactics I tried my best to stay true to my original concept at the thumbnail stage. If you ever feel you are losing your way at this late stage of a painting, step back and look at your thumbnail. This should prevent you becoming lost in detail.

(Left) A small conical bush to the left of the temple had become too dark. Using the lift-off technique I therefore lightened it and dropped a bright yellow into the exposed area. Bright oranges were then painted over the fretwork and rails of the temple giving an extra lift to the colour on this important focal point. To the right of the temple, highlight colours were painted across the gate

and the flowering foliage. The red flowers not only acted as a foil to the greens, making them look brighter (the old Constable trick again), but gave depth by disappearing behind the large foreground tree.

Small areas of rewetting, such as this, were achieved by using a flat nylon brush held flat against the surface. To rewet larger areas such as the yellow flowers, I used a hake.

These yellow flowers, and the yellow-green foliage, were painted with very strong, bright colours as I wanted to allow for the fact that watercolour loses impact as it dries. Downward strokes of orange were then pulled across the top part of the water to hold it together and act as a foil to the bright green foliage above. This same colour was used in the foreground on the left bank, to soften its edge.

(*Below*) The foreground of this picture required considerable restraint. It would have been easy to amass detail on an area so close. To have done this would, unfortunately, have been detrimental to the focus of the painting which was the temple and its yellow bushes.

The most difficult aspect of watercolour painting is to decide when *not* to paint. Look at the photograph again and note the details I selected.

The foliage to the left and the grasses along the bank were understated. The two trees on the right were strengthened with scumbles of warm colours and linework (into wet) to give some contrast and internal textures.

I used counterchange to great effect in this painting to give the foreground maximum light. I applied

this technique in the following areas:

• The foreground bank itself which moves from dark at the right-hand side to a much lighter tone as it nears the water, so that we have a strong edge where the two meet.

• The foliage in the foreground is light on the left and dark on the right.

• The foreground tree trunks are light, even white, against the dark distant trees but dark against light areas.

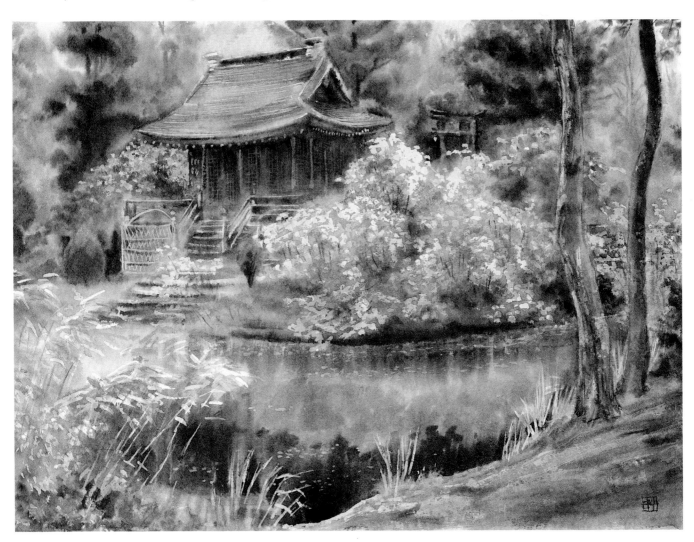

Wet on Wet: Working In The Field

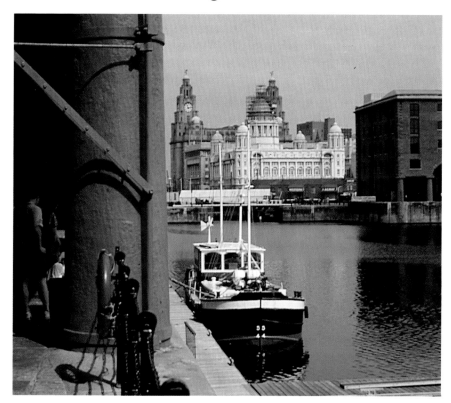

(Below left) I lifted colour from the following areas: the right-hand side top edge of the pillars; the front face and windows of the warm building on the right; the pontoon and vertically from the water.

Richer colours and contrasts were then worked into the shadow areas of the pillars and building to the right. Its glass roof and the skyscraper behind were indicated to give a more interesting silhouette against the sky.

I applied resists of wax and masking fluid to the water to create surface detail when further dark washes were dragged vertically over them.

Darker blues were dropped into the sky to give greater contrast against the central building and the boat and the pontoon were sharpened with dark accents.

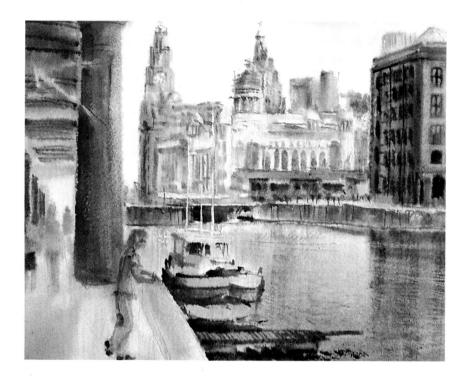

(Opposite page, top) I then applied some masking fluid to the main foreground figure to give her focus. Elsewhere all the mask was removed.

Once dry, some middle tones and accents were laid over this figure to increase her solidity. Note how she stands out against the other figures which have been deliberately blurred.

The foreground water under the pontoon and boat were darkened to increase its reflective quality.

Highlights to the walkway, windows and roof spans were lifted off, and then darkened with purple washes. I used a wax resist at the far end of the walkway to suggest light and to give a soft focus.

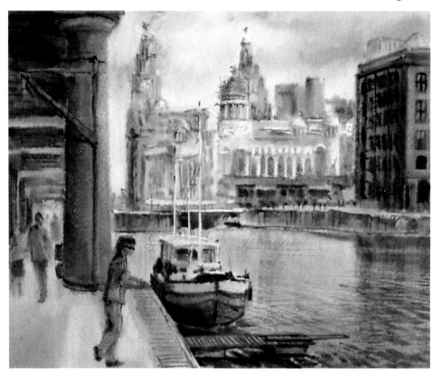

(Below) Having lifted off the masking fluid from the figure, I painted in the chain-link fence with stiff colour. When dry, highlights were lifted off. In this way it did not become too dominant. Notice how I have omitted the last swag of the chain, so the eye was not carried out of the picture.

The cobbles were laid using a warm stiff colour, applied so as not to overpower the figures or draw too much focus to this area.

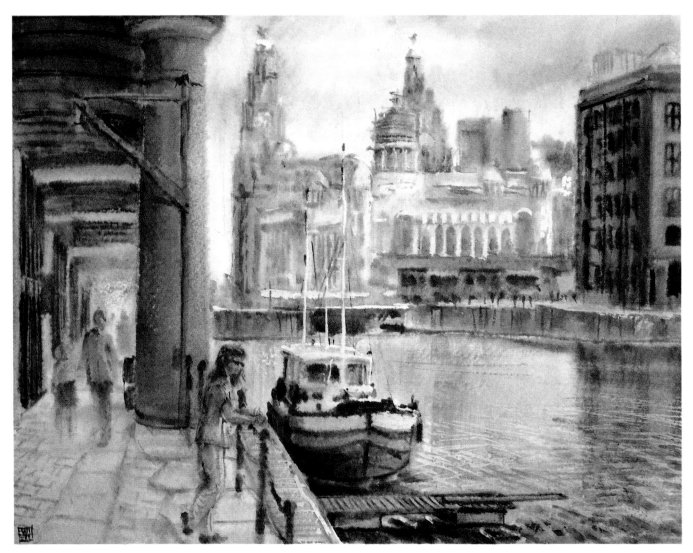

Wet on Wet: Common Problems

PROBLEM Going back or working too long into a wet-on-wet wash causes uneven drying which leads to ugly textures and hard edges.

SOLUTION Lay wet-on-wet washes quickly and evenly. Allow to dry then rewet if necessary and lift off or add colour.

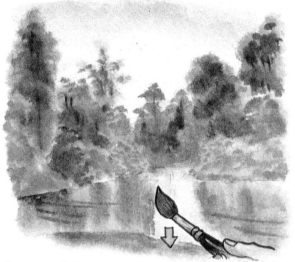

PROBLEM Surface dries too quickly and hard edges occur unexpectedly.

SOLUTION If there are many hard edges wait until dry and lift off. If there are only one or two and the surrounding washes are relatively dry, lose the hard edges before they dry (as in wet on dry). The problem can be avoided by soaking the paper or allowing it to dry and rewetting before continuing.

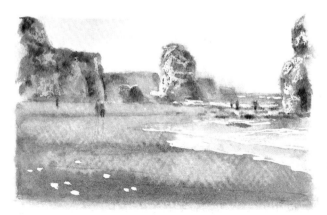

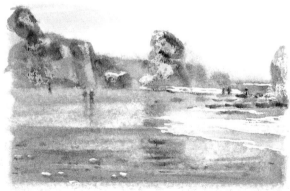

PROBLEM An area of lift off becomes unpleasantly textured.

SOLUTION Allow the washes to dry thoroughly before attempting lift off, or use smooth absorbent tissue to lift off.

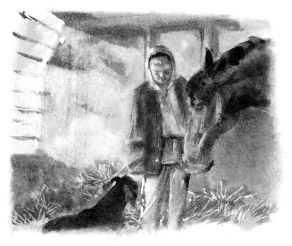

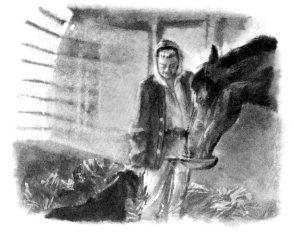

PROBLEM Lift off becomes difficult to control and too much paint is removed on second and third attempts.

SOLUTION After each lift, allow the surface to dry throughly before attempting the next. If necessary use a hair dryer to speed up the process. You could also try using a softer brush or exposing the surface to wetness for as short a time as possible.

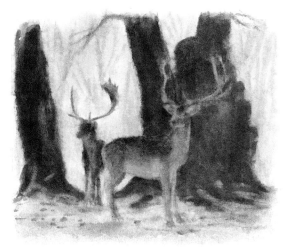

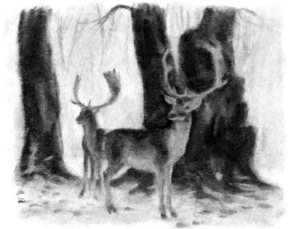

PROBLEM When trying to mix dark colours, they won't go dense enough unless mixed with their complementary colour and then they become too dull.

SOLUTION Mix the colour in layers. First lay your complementary colour and, when this is dry, your chosen colour. This gives a rich finish.

PROBLEM The painting is tonally weak and textured unevenly.

SOLUTION Use a larger brush which holds more pigment and allows a much more suggestive application of the paint, especially if you use the side of its head to cover large areas with a smooth wash.

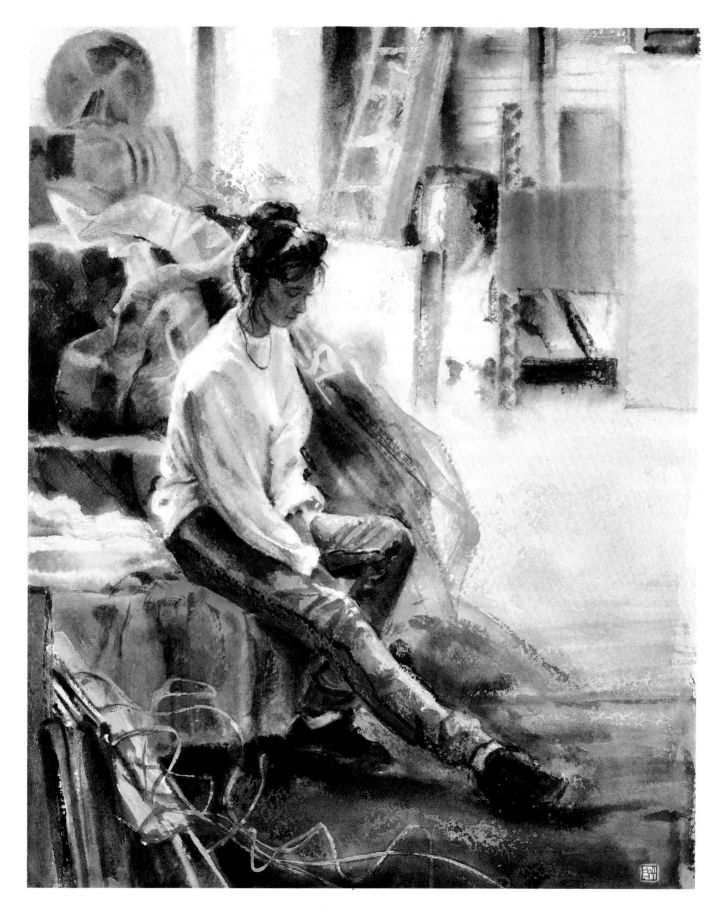

Combination Techniques

I hope that by the time you read this chapter you will have given each of the watercolour techniques some of your time. It is only through constant practice that the qualities inherent in each approach will become second nature. You may feel that you have a liking for one particular area, or you may feel that you would rather change your techniques according to the subject matter. Each one has its own particular qualities.

You will already have discovered that you can combine techniques, such as applying resists, across the board. Illustrators of children's books often use a combination of wet on wet, lift off and line (*see page 120*).

In this technique the colour areas are blocked in much too heavily using wet on wet. The lighter tones and volumes are then established by lifting off. This imparts a particular textural quality which varies according to the paper surface. The work is then completed with a very strong but very discriptive line in black or dark ink. Have a look at some illustrated books and you will soon spot this technique.

It is easy to understand why illustrators employ this technique. The colour tone is very easy to control with lift off and all the detail is carried by the line.

In my previous descriptions of line and wash, for example, I added the colour to the line using a wet on dry technique. There is no reason why wet on wet could not have been employed. One of the problem areas in line and wash is balancing the strength of your line and the hard edges of colour. With wet on wet you would not have an edge and therefore you could use much stronger colours.

Each artist will eventually discover the combination which suits their needs and personality. Just think of the possibilities that this presents to you.

A word of advice here, you will not develop your own personal style by copying other artists. Certainly, look at other people's work. Don't be discouraged if they are a little better than you. Let the fact that they have had a chance to explore and nurture their own potential inspire you to do the same.

Paint from nature and your style will develop by itself. Your selective view of the world will be your signature. I have had groups of 30 people all painting the same view, and at the end of the session we have had 30, quite different, paintings.

The combination that I particularly favour is two layers of wet on wet with one layer of wet on dry. The idea being that the first layer of wet on wet establishes the main masses of the picture and the lightest colour within each of these areas. Once this layer has dried, resist can be added or unwanted areas lifted off. By rewetting the painting in small sections only, control is maintained so that the edges do not dry hard. The darker colours now added give soft-edged details which are still out of focus. After drying, resists or lift off can again be employed.

The final layer is wet-on-dry, applied using two brushes so that edges can still be softened or lost where necessary. Remember, if they are left hard, the eye focuses on them and therefore our attention is carried straight to them. They must, therefore, be applied with the utmost care.

You have to balance how much focus you require in your painting. If you have particular focal points, then they must be accurate and remember that where they occur you will tend to lose the suggestion of depth and movement. However, correctly placed focal points can lead the eye around a picture.

The picture is finished by removing the resist, lifting off any mistakes and by adding the occasional line accent.

This painting of the resting girl and that of the garden in this section have differing degrees of focus as they both have different functions to perform. Look closely at both paintings and note the difference between them.

Combination Techniques: General Hints

This study has made use of the fine detail attainable through the use of line and the soft colour of wet on wet. Line comes into its own when depicting architectural forms. Here, however, I also needed soft colour to suggest the glowing light and wet street. Soft paint, without edges, does not conflict with the drawing and can often be applied more densely than the hard edges of wet on dry. It is also for this reason that the line required no strengthening as, even in dense areas of paint, it retained its dominance.

Here, I have applied a technique widely used by illustrators. A fine-line Indian ink drawing was overlaid with very heavy wet-on-wet colours. Once dry, the highlights were achieved using lift off. A second layer of line, using diluted ink, was then applied to areas of texture, for example the tree, bark, hair and leaves. Undiluted ink was then applied to some of the silhouette edges of forms such as the trees and figures, to make them stand proud.

Here I used line and wash again, with colour applied using wet on wet. However, on this occasion I used a variety of resist techniques to suggest the texture of the pine cones and bark. Masking fluid was applied to highlights before any colour was applied. Once the first layer had dried, the masking fluid was removed and wax applied to give softer textures to the second layer of paint. Finally, the line silhouettes were strengthened because the power of the textures began to obscure their form.

This has the effect of throwing detail in and out of focus. Observation must be very keen for this technique to succeed as it will not take many layers of paint before becoming confusing. However, it is fast and exciting, and well worth the effort of mastering.

Gouache is an opaque watercolour, generally regarded as designers' colour as, when used thickly, it produces flat, even layers of colour.

However, when thinned down it can be used in the same way as watercolour. Its opacity can be used to advantage by working on coloured paper. The colour of the paper is a significant factor in the colour balance of the composition as a whole. Note how white has been used here as an applied colour against the coloured background paper.

Generally, it is thought best to avoid using white as a pigment as it seldom has the power that the white of the paper possesses. This does not mean that it *cannot* be used. Chinese white, the true watercolour white, is slightly transparent but I find it ineffectual and therefore find it quite useful to mix my media, here using an acrylic Titanium white which is much stronger. It also has the ability to fix any strong colours which may bleed through from underneath. One note of warning – don't allow any acrylic paint to dry in your brushes as it can ruin them in minutes. The seascape below has white in the mix used for the sky, the land and the highlights on the sea.

I only used two layers to complete this simple study of trees and water. I rewet selective areas with a nylon wash brush, just before applying the paint. In this way, soft edges are produced in the wet areas and hard edges in the dry ones.

Combination Techniques: Step by Step

One of my recent commissions was to produce a series of watercolours for a book on gardens. My task was to translate a series of ten garden plans into paintings that would demonstrate how the gardens would look in reality.

It was a considerable challenge to produce a painting of an imaginary garden, while conveying a feeling of that garden existing. The publisher wished to veer away from the typically illustrated artist's impression and give each garden design substance. My references were a flat plan and a mountain of information on plants, garden ornaments and so on.

Each of the gardens was painted using my favourite combination technique – two layers of wet on wet, followed by one layer of wet on dry.

I wet the top third of the painting with a hake and applied the first highlight colours to the sky, distant trees and building. The bottom of the painting was now dampened and I indicated the position of the path with its areas of sunlight and shade. I then wet the spaces either side of the building and painted in the hedges.

The drawing had to be very comprehensive as I had to depict a variety of flowers. I used a 0.5 mm clutch pencil to render the majority of the line finely enough to be overpainted. Masking fluid was widely applied to the flower heads and other highlight areas.

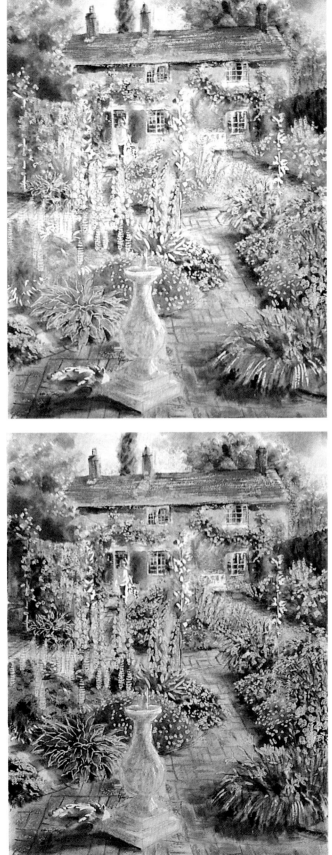

(Above) I now applied the first layer of colour to the foliage, again exploiting the use of warm and cool greens to portray sunlight and shade. The flower heads were to be an important aspect of the finished painting so it was important to keep their background foliage as soft as possible. I decided, therefore, to paint the majority of the leaf detail with soft wet-on-wet textures. The figure, cat and sundial were now added to give focal points and, when dry, some of the masked areas were removed except those protecting the flower heads. This saw the completion of the first layer of wet on wet.

(Above right) Candle-wax resists were now applied sparingly to the sky, the brickwork of the building, to the foreground of the path and to the sundial. Masking fluid was used over the roof, window frames and some of the green foliage in the foreground. The painting was then rewet in sections and the colour of the sky, distant trees, building and pathway was strengthened. Note how I have used complementary mixes of reds and purples in the shadow areas.

(Right) The foliage areas were rewet in sections and strengthened with blue greens, red greens and purples in the shadow areas, and yellow greens in the areas of sunlight. For rewetting the small areas I used my flat nylon wash brush which restricted the amount of water the surface had to accept and reduced the possibility of accidental lift off.

Combination Techniques: Step by Step

(Right) When the surface was completely dry the masking fluid was removed from the entire painting, with the exception of the sundial. Great care was taken to remove all the mask without tearing the surface. I always become very excited when lifting off so much resist for it is almost like discovering a new painting – but don't get so excited that you rush the job. If you damage a painting at this stage you will not be so pleased with yourself.

(Below) I rewet the areas around the figure, the flowers on the building, the cat and the sundial and overlaid them with bright colour. The masking fluid was removed from the sundial and complementary purple textures were scumbled over the path – note the counterchange effect achieved with this colour against the edges of the sundial. This completed the second layer of wet on wet.

(Below right) It was only at this late stage that I added colour to the flowers, whereas many beginners would have begun their painting with the flowers. This is one of the many examples of the advantage that can be gained from studying your subject matter before you start. The flowers are, of course, the most exciting part of the painting to complete, but they need the contrast of the soft darks behind them to make their colours really sing out. I avoided the use of complementary hues for the shadow colours in the flowers, to prevent the loss of intensity. Shadows were achieved by applying more pigment of the same hue (or a slightly cooler one).

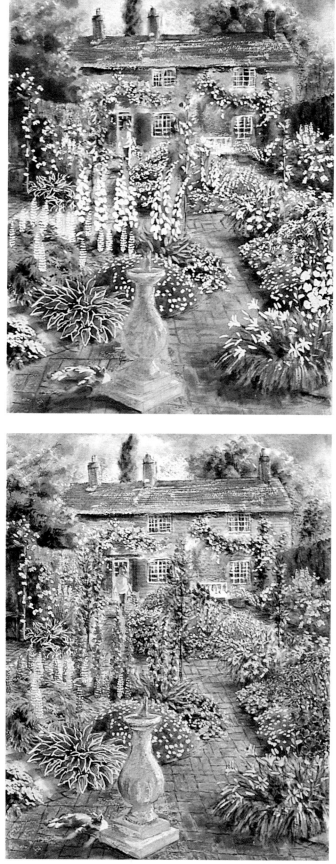

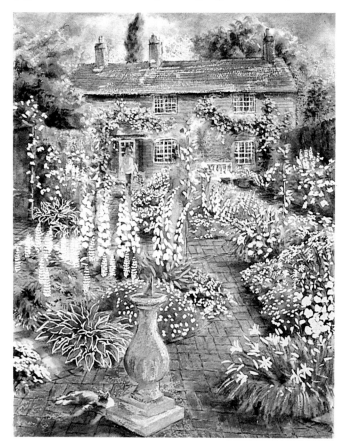

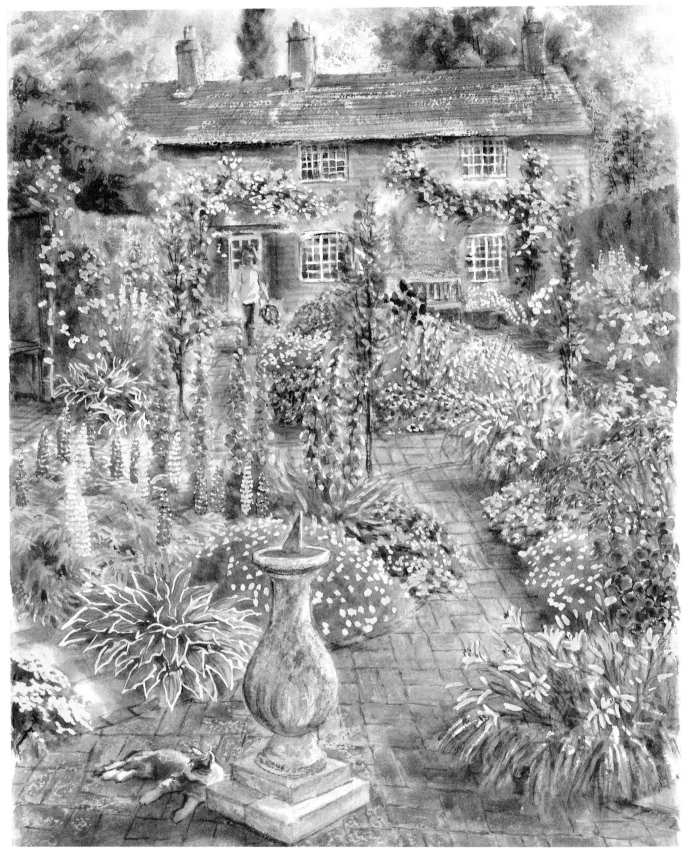

Fine detail was now applied to the focal points, for example, to the house, the figure, the sundial and the cat. Note how in the scumbling on the sundial the brush-marks follow the shape of the object, the purpose of which is to suggest volume. Holding the painting up to a mirror (a good way to objectively assess the progress of any painting), I concluded that I had pretty much fulfilled my original intentions and was satisfied with the result.

Acknowledgements

There are many people to whom I owe 'thank-yous'; including my family and close friends who have supported and encouraged me.

This book would not exist if it were not for my Publishing Director, Hilary Arnold, who demonstrated considerable confidence in me. It was she who had faith enough in my work to commission me to produce this book. Cindy Richards, editor, and Behram Kapadia, designer, helped to make the work a totally enjoyable experience, not withstanding their invaluable professional expertise which brought the book to life.

Others include Sam Youd, Head of Gardens at Tatton Park, Knutsford, Cheshire, for allowing me to share the delightful gardens there. Many a painting has been inspired by them, as has the cover of this book which shows me at work in the Tower Garden.

To Osborne & Butler, suppliers of all the art materials and paper which were needed to produce the illustrations and paintings – thank you for your excellent service.

And finally to Eileen Tunnell whose enthusiasm, positive thinking, organisation and careful management carry me over the many hurdles to be overcome in a life such as mine.

Materials used in production of illustrations and paintings

PAPER:

Fabriano Artistico Rough and Hot Pressed (300 gsm [140 lb] and 600 gsm [300 lb])

PAINT:

Maimeri Artisti Extrafine Watercolours
Cadmium Red Deep
Alizarin Carmine
Cadmium Yellow Deep
Primary Yellow
Ultramarine
Prussian Blue

BRUSHES:

Osborne & Butler Round Sable Series 990
Osborne & Butler Flat Wash-Nylon Series 991
Osborne & Butler Hake Series 993S

EASEL:

Maimeri Portable Wooden

MASKING FLUID:

Maimeri

OX GALL:

Maimeri

TURPENTINE ESSENCE:

Maimeri

PUTTY RUBBER:

Maimeri